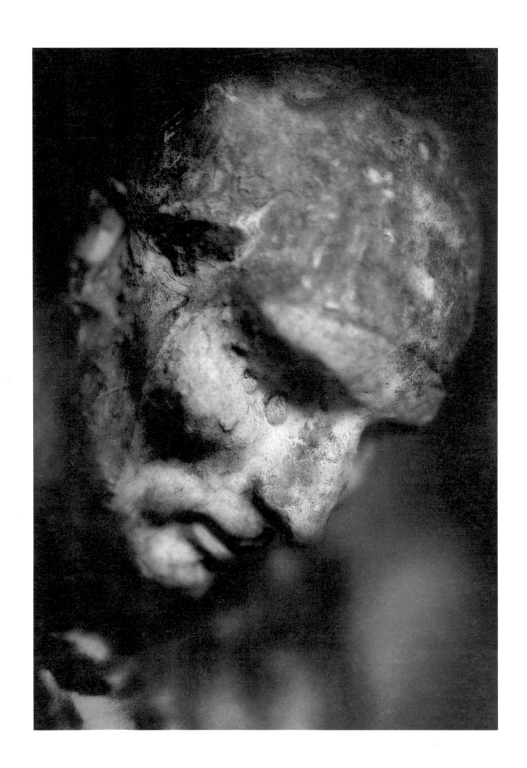

Rainer Maria Rilke

Auguste Rodin

Translated from the German by Daniel Slager
Introduction by William Gass

archipelago books

Library of Congress Cataloging-in-Publication Data
Rilke, Rainer Maria, 1875–1926.
[Auguste Rodin. English]
Auguste Rodin / Rainer Maria Rilke ;
translated from the German by
Daniel Slager. – 1st ed.
p. cm.
ISBN 0-9728692-5-5
1. Rodin, Auguste, 1840–1917 – Criticism and interpretation. I. Title.
NB553.R7R6513 2004
730'.92–dc22 2003021339

Archipelago Books
New York, New York
www.archipelagobooks.org

Distributed by Consortium Book Sales and Distribution
1045 Westgate Drive
St. Paul, Minnesota 55114
www.cbsd.com

9 8 7 6 5 4 3 2 1

CONTENTS

Rilke's Rodin

an introduction by William Gass

Part I (1902)

Part II (1907)

RILKE'S RODIN

WE CAN PRETEND TO KNOW PRECISELY. At three o'clock on the Monday afternoon of September 1, 1902, bearing the appropriate petitions of entry, although he had arranged his visit in advance, the twenty-six-year-old poet Rainer Maria Rilke appeared on the stoop of Auguste Rodin's Paris studio, and was given an uncustomary gentle and courteous reception. Of course Rilke had written Rodin a month before to warn of his impending arrival. It was a letter baited with the sort of fulsome praise you believe only when it is said of yourself, and it must have been an additional pleasure for Rodin to be admired by a stranger so young, as well as someone with a commission to write of the sculptor and the sculptor's work as handsomely as, in his correspondence, he already had. Rilke was enthusiasm in a shabby suit, but Rodin, who paid little mind to social appearances except when he was mixing with potential clients, was willing to set aside some time for a chat while suffering the foreigner's fledgling French without complaint. He could not have realized that he was going to be the victim of a role reversal, because it was the artist who would play the sitter for a change. Rilke had arrived with an anticipatory portrait well advanced, and his tireless pen immediately began making mental corrections. "... it seemed to me that I had always known him," he wrote his wife, Clara, the following day. "I was only seeing him again; I found him smaller, and yet more powerful, more kindly, and more

noble. That forehead, the relationship it bears to his nose which rides out of it like a ship out of harbor . . . that is very remarkable. Character of stone is in that forehead and that nose. And his mouth has a speech whose ring is good, intimate, and full of youth. So also is his laugh, that embarrassed and at the same time joyful laugh of a child that has been given lovely presents."[1]

Released to explore the studio and its holy objects, Rilke discovers, almost immediately, a hand: *"C'est une main comme-ça,"* Rodin says, gesturing so impressively with his own broad blunt peasant hands with their plaster white fingers and blackened nails that Rilke fancies he sees things and creatures growing out of them. In Rilke's steamy state of mind Rodin's every word rises in the air, so that when he points to two entwined figures and says: *"c'est une création ça, une création . . ."* the poet believes, he reports to Clara, that the word *'création'* "had loosed itself, redeemed itself from all language . . . was alone in the world."[2] Everything small has so much bigness in it, he exclaims to his page.

Rilke tries to take everything in as if there will not be a next day, but there is a next day, and at nine he is on the train to Meudon, a twenty-minute ride to transformation. The town clings to a hillside from whose crest the Seine can be seen snaking its way to Paris. He walks up a "steep dirty village street" to Rodin's villa called des Brillants which the sculptor had bought in 1895. Rilke describes the journey to Clara with the sort of detail one saves for wonders of the world: over a bridge – no voilà yet – down a road – no voilà yet – past a modest inn – no voilà yet – now through a door in the villa wall that opens on a gravel path lined with chestnut trees – still no voilà – until he rounds a corner of the "little red-yellow house and stands" – voilà now! – "before a miracle – before a garden of stone and plaster figures."

Rodin had transported the Pavillion de l'Alma, in which he had exhibited his work in Paris in 1900, to the small park surrounding his house where there were already several studios set aside for cutting stone and firing clay. The pavilion was a heavily glassed light-filled hall full of plaster figures in ghostly confabulation, and it also contained huge glass cases crammed with fragments

[1] Letter to Clara Rilke, Tuesday, September 2, 1902. *Letters of Rainer Maria Rilke 1892–1910,* translated by Jane Bannard Greene and M.D. Herter Norton, New York: W.W. Norton, 1945, 77–78.
[2] Ibid., 78.

from the design of *The Gates of Hell*. "There it lies," Rilke writes, already composing his monograph,

> yard upon yard, only fragments, one beside the other. Figures the size of my hand and larger . . . but only pieces, hardly one that is whole: often only a piece of arm, a piece of leg, as they happen to go along beside each other, and the piece of body that belongs right near them . . . Each of these bits is of such an eminent, striking unity, so possible by itself, so not at all needing completion, that one forgets they are only parts, and often parts of different bodies that cling to each other so passionately there.[3]

Rilke had brought a sheaf of his poems which Rodin dutifully fingered although he could only admire (as Rilke imagines) their pose upon the page; otherwise he left Rilke to roam about the place examining its treasures. The poet poured out upon these figurines and fragments a bladder full of enthusiasm as was his pre-Paris habit ("each a feeling, each a bit of love, devotion, kindness"); but the city's unyielding and indifferent face and the sculptor's dedicated work habits would teach the poet to see his surroundings as they were in themselves and not simply allow his glance to fall like sunshine on surfaces where it could admire its own reflection and its glitter.

Then it was lunchtime. And the first lesson, *en plein air*. They sat five at a trestle. No one was introduced. There was a tired looking, nervous, and distracted lady whom Rilke assumed was Madame Rodin. There was a Frenchman notable for a red nose, and "a very sweet little girl of about ten" who sat just across from him. Rodin, dressed for the city, is impatient for his meal. Madame replies with a torrent of apparent grievance. Rilke begins to observe – *regarde! regarde!* is the new command – and sees Madame giving forks, plates, glasses little pushes that disarray the table as if the meal were already over. "The scene was *not* painful, *only sad*," he writes. The Master continues to complain as calmly as a lawyer until a rather dirty person arrives to distribute the food and insist that Rilke partake of dishes he does not desire. The poet should

3 Ibid., 79.

3

have been hungry, he was on his uppers, but he was also finicky to a fault, vegan of a sort, a fancied sign of his ethereal nature. Rodin rattled on agreeably. Rilke spoke of his art colony days in Worpswede and of the painters he met there, few of whom Rodin had heard of, although that would not have surprised the poet had he realized that his acquaintances, his friends, were nobodies. And as a poet, he was invisible in this space.

Because it was full of blazing plaster casts in a pavilion that gathered light as if it were fruit. "My eyes are hurting me, my hands too," he wrote to his wife. Madame Rodin was gracious after lunch, inviting him back, as we say, "anytime you're in the neighborhood," little realizing, I imagine, that for Rilke that would be tomorrow.

And so ended the second day.

Nothing is more fragile than adoration, yet Rilke's adulation might have remained that intense, agreeably decorating a dirty pane like a window's curtain, had he not sunk into an outcast's life. Poor, alone, he sought refuge from the friendless Paris streets in the Bibliothèque Nationale, often from ten to five; or he fled by train to Meudon and its sheltering plasters, kinder to his eye though they blinded him than the beggars who would offer him their misfortunes for a franc; while evenings he passed in the squeeze of his room writing letters to his wife as forlornly beautiful as letters get. The poet was, among other things, an inadequately educated youth who would play the poet even on those days he wasn't one, and who sought to unite his spirit with the spirit of his poems, so as to live several feet above the ground. Yet the great sculptor would eventually prove to be a crude rude clown, a satyr in a smock, who was losing his strut, caught in the curves of female connivance and flattery only to be led around eventually (in Sir Kenneth Clark's estimation) like a dancing bear.[4] So loyalty would demand that Rilke separate the man from his art, a split easier for a Solomon to decree than a babe to endure, and an act at odds with his inclinations.

Moreover, the fragments he so admired in Rodin's workshops, alive in every brief line that defined them, were confronted by the ugly realities of the avenues, poor creatures who every day looked more like himself.

[4] Clark, Kenneth. *The Romantic Rebellion*. New York: Harper & Row, 1973, 353.

They were living, living on nothing, on dust, on soot, and on the filth on their surfaces, on what falls from the teeth of dogs, on any senselessly broken thing that anyone might still buy for some inexplicable purpose. Oh what kind of world is that! Pieces, pieces of people, parts of animals, leftovers of things that have been, and everything still agitated, as though driven about helter-skelter in an eerie wind, carried and carrying, falling and overtaking each other as they fall.[5]

In these lines written in Worpswede during the following summer he relived for his former mistress's benefit his Paris suffering. Rilke was also rehearsing what would become the magical opening pages of his novel, *The Notebooks of Malte Laurids Brigge.* It is worth quoting a bit more in order to demonstrate the psychologically stressful difference between the euphoric celebrational style of the first Rodin monograph and its author's daily state of mind.

There were old women who set down a heavy basket on the ledge of some wall (very little women whose eyes were drying up like puddles), and when they wanted to grasp it again, out of their sleeves shoved forth slowly and ceremoniously a long, rusty hook instead of a hand, and it went straight and surely out to the handle of the basket. And there were other old women who went about with the drawers of an old night stand in their hands, showing everyone that twenty rusty pins were rolling around inside which they must sell. And once of an evening late in the fall, a little old woman stood next to me in the light of a store window. She stood very still, and I thought that like me she was busy looking at the objects displayed and hardly noticed her. Finally, however, her proximity made me uneasy, and I don't know why, I suddenly looked at her peculiarly clasped, worn-out hands. Very, very slowly an old, long, thin pencil rose out of those hands, it grew and grew, and it took a very long time until it was entirely visible, visible in all its wretchedness. I cannot say what produced such a terrible effect in this scene, but it seemed to me as if a whole destiny were being played

[5] Letter to Lou Andreas-Salomé, July 18, 1903, op. cit., 109.

out before me, a long destiny, a catastrophe that was working up fright-
fully to the moment when the pencil no longer grew and, slightly trem-
bling, jutted out of the loneliness of those empty hands. I understood
at last that I was supposed to buy it.[6]

In the novel, Malte eventually realizes with horror that he has become an
accomplice . . . another shabby person of the street.

> . . . when I noticed how my clothes were becoming worse and heavier
> from week to week, and saw how they were slit in many places, I was
> frightened and felt that I would belong irretrievably to the lost if some
> passer-by merely looked at me and half unconsciously counted me
> with them.[7]

Perhaps, when you only beg from the best families and the finest founda-
tions, you can call yourself a development officer, but where Rilke was living
now there were no banks, no fancy estates occupied by susceptible titled ladies,
just *Aisles d'Nuits,* the *Hôtel Dieu,* and other *hospices de la maternité.*

The path to Paris had been a circuitous one, the result of flailing more than
plan. At Christmas, two years before, Rilke had returned to Prague to visit his
mother, always a trying time for him, although Santa brought him a new brief-
case, and on his way home he stopped in Breslau to visit an art historian,
Richard Muther, whom he hoped might agree to tutor him in this vast field,
since Rilke was now considering a career as an art critic. Perhaps Muther might
help him combine this fresh but desperate interest with a trip to Russia that
Rilke was planning. It would be his second.[8] Muther was presently the editor of
some pages on art for a Viennese weekly called *Zeit,* and he suggested that Rilke
write something on Russian art for its pages. Rilke promptly did so and com-
posed another article after he had completed his trip.

When they met again it was at the newly married couple's cottage near the
art colony of Worpswede, outside Bremen. Rilke's second essay was about to

[6] Ibid., 109, 110.
[7] Ibid., 111.
[8] Ralph Freedman. *Life of a Poet: Rainer Maria Rilke.* New York: Farrar, Straus and Giroux, 1996, 108.

appear. Muther had just completed a monograph on Lucas Cranach and sent a copy ahead of his arrival. His hosts showed him studios and introduced him to painters as a part of their mutual cultivation. A few months later, Muther would get his review and Rilke receive the Rodin commission. In that regard he had an edge his youth and inexperience could not dull: his wife, Clara, was herself a sculptor who had studied with the Master and for that reason they had initially planned to do the piece together. Clara's previous relationship might be expected to make entrée easier.

Rilke was eager to get out of his honeymoon house, a cute thatch that had lost a good deal of its charm after Clara had given birth. Babies often allow wives to feel they have done their sexual duty and husbands to feel they have been warned: what the house now holds will hold them. Clara was also anxious to return to work and would eventually join Rilke in his Paris penury after she had dumped little Ruth with her grandmother. (The word 'join' suggests more intimacy than was sought since they maintained separate lodgings.) The commission was urgent because the couple's funds were nearly exhausted, and, although Clara insisted on paying her own way, Rilke's sources of charity were drying up.

Rilke was learning on the run. He had no scholarly skills. Confronted by a mass of materials, he tended to freeze. "Instead of taking notes on a text with concentration and efficiency, he was forever tempted to copy the entire book."[9] There were many things about his subject he would have known, for they were in the air as well as the newspapers or came from Clara's recollections. But some of the things he thought he knew were wrong and some of the things Rodin revealed about himself weren't true: that he had married *"parce qu'il faut avoir une femme,"*[10] for instance, since he would not marry Rose Beuret, the woman he had – unlicensed – lived with from 1864, when she had become his model and his mistress, until their approaching deaths made such legalities matters of concern. (Rose died in October of 1917, he in November, less than a month later.)

Rodin had been born a profligate and it had apparently always been neces-

[9] Wolfgang Leppmann. *Rilke: A Life.* Trans. by Russell Stockman. New York: Fromm Intnl., 1984, 174.
[10] Letter to Clara Rilke, September 5, 1902, op. cit., 84.

sary to have a woman . . . or two. Waiting to pose, nude or nearly, a pair of models might lounge around the studio. When they did, they often had to assume and maintain athletically strenuous erotic positions for extended periods while he drew – comfortably wrapped – in a room Rose kept cool to save sous and suppress inclinations, although often, nearer his models and more discreet, Rodin worked at the *Dépôt des marbres* in Paris. "Moving constantly around him as he worked were several nude models. He watched them as they moved, like Greek gymnasts, establishing a familiarity with the human body, and with muscles in movement."[11] Occasionally he would insist they caress one another. His artistic excuse for these practices was that through them women were psychologically laid bare not merely their thighs and bosoms. Rilke, predictably, put a feminist spin on these images. Speaking of figures on *The Gates of Hell,* he says: ". . . here the woman is no longer an animal who submits or is overpowered. She is too awake and animated by desire, as if they had both joined forces to search for their souls." During such times that the models moved or froze in the midst of a gesture the artist worked with great rapidity, sheets of drawings literally flying from his pad to litter the floor. At a more leisurely moment, he would apply a light wash of color to the graphite.[12] Rodin did not conceal his erotic drawings from less candid eyes but exhibited them more than once. The Musée Rodin has many thousand such sketches. Later, Picasso would exhibit a similar unremitting libidinous energy.

Without warning, the maestro would disappear for weeks from beneath Rose's eye.

> These absences sometimes corresponded to brief encounters with one of his models or with one of the innumerable society women, whose appetites were aroused by his reputation as a lover. But when, to excuse himself, Rodin put up a sign on the door of Studio J of the *Dépôt des marbres* which read: "The sculptor is in the Cathedrals," it was sometimes true he was visiting them.[13]

[11] Sue Roe. *Gwen John: a Painter's Life.* New York: Farrar, Straus and Giroux, 2001.

[12] Albert Elsen. *Rodin.* Museum of Modern Art. New York: Doubleday, 1963, 165.

[13] Robert Descharnes and Jean-François Chabrun. *Auguste Rodin.* Translation from Edita Lausanne. Secaucus, N.J.: Chartwell Books, 1967, 118.

Four years before Rilke's arrival, Rodin had broken off an extended affair with Camille Claudel, the gifted sister of the great poet and playwright Paul Claudel, and a splendid sculptor herself, with disastrous consequences for Camille who had to be institutionalized, though there were doubtless other reasons for her paranoid delusions. She and Rosa had passed through words to come to blows, and it is said (by those who say these things) that Camille had a habit of lurking about the grounds and that Rosa had once fired a shot in the direction of some concealing plants. Camille's brother, whose Catholicism was central to his work, was not Christian enough to forgive the sculptor such a prolonged misuse of his sister, but in this case forgiveness might have been a fault.

As for Rodin, he was nearsighted: he had the big bulging eyes of a lecher. When he worked he had his nose right on the model and on the clay. Did I say his nose? A boar's snout, rather, behind which lurked a pair of icy blue pupils. In all his sculpture, what you have is his nose working together with his hand, and sometimes you catch the face emerging from the very middle of the four fingers and the thumb. He tackles the block as a whole. With him everything is compact, massive. It is dough that gives unity. His limbs tend to get in the way.

How different from my sister's light, airy hand, the sense of excitement, the perpetual presence of the spirit, the intricate and sensitive tendrils, the airiness and play of inner light![14]

While Rilke was in attendance, Rodin took up with Gwen, another sister, this time of Augustus John. She would survive the experience to become a talented painter though she never married and the little village of Meudon held her fast her entire life.[15] Through Gwen John's letters we can follow the progress of their affair and get an idea of how many of these amours must have taken a similar path, because, if it was a unique romance for each woman, it

[14] Ibid., 130. In *L'oeil écoute* (The Eye Listens) Claudel had written extensively about Flemish art and praised it in particular for capturing "the movement of human life toward its conclusion." In contrast, Rodin's art would have had to seem profane.
[15] Roe, op. cit., chapters 6 & 7.

was an established routine for the artist, who was consequently always in charge. As girls they came to Paris to make art their career; they sought work as a model in order to pay their way; sometimes they would pose for a painter who posed for Rodin and that way achieve an introduction. In Gwen's case, it was her suppleness that initially appealed to the Master, though other women doubtless had their own special qualities. Soon he would be singling her out, lending her books, asking her to make copies of certain passages he would mark for extraction, and then – la coup de coeur – requesting to see her work. One day, while she was in a half-naked, knee up, head bowed, prancing pose for the Whistler memorial statue, the kiss arrived. "I can feel, rushing across my lips, sensations of mystery and intoxication," she told him.[16] Gwen will dream of giving up all for him (especially her career), of becoming his wife, of taking his material tasks in hand and, though not a tidy, enterprising person, organizing his life. For this last task, Rodin would solicit and seduce Rainer Maria Rilke.

In his two monographs, Rilke will touch on such matters so discreetly not even he will avow his knowledge of them; but the contradiction between Rodin's life of quarrelsomeness, deceit, and sensual indulgence and his consuming artistic dedication; the difference between the studio's dusty physicality, and its apparent product – abundant beauty and grace arising out of clay, marble's serene cool glisten like light in a water glass, lofty ideals caught in casts of plaster – these militant contrasts govern every line of the poet's essays – where Rilke enlists awe to ward off consternation – just as they control every surface of the artist's sculptures, including the version of the Balzac memorial that depicts the novelist with an erection. After George Bernard Shaw sat for his bust by Rodin, he wrote that "The most picturesque detail of his method was his taking a big draught of water into his mouth and spitting it onto the clay to keep it constantly pliable. Absorbed in his work, he did not always aim well and soaked my clothes." [17]

On Rilke's next visit Rodin held class. After a lunch which resembled the

[16] Ibid., 56.
[17] Quoted in Elsen, op. cit., 126. Rodin's impact on Rilke, from the French point of view, is thoroughly discussed by J.F. Angelloz in *Rainer Maria Rilke – l'Evolution spirituelle du poète*. Paris, 1936, and by K.A.J. Batterby in *Rilke and France: a Study in Poetic Development*. London: Oxford University Press, 1966.

first in everything but menu, they sat on a bench that had a fine view of Paris while Rodin spoke of his work and its principles. Rilke has to run after Rodin's rapid French as though for a departing bus. The sculptor's work is manual like that of a carpenter or mason and produces an object unlike the memos of an office manager, consequently, to the young, the calling has lost its attraction. They don't care to get their hands dirty, but *"il faut travailler, rien que travailler"* he likes to repeat. In fact, Rodin did little if any carving (or welding either, of course), although it is said that he liked to greet people at the door head to toed with dust and fisting a chisel. His bronzes were cast, his marbles carved, by workers he rarely saw.[18] Henri Lebossé enlarged the sculptor's plaster models to the dimensions proper for a public monument.[19] Rodin complains that the schools teach "the kids nowadays" to compose – to emphasize contour rather than to model and shape surfaces. *". . . ce n'est pas la forme de l'object, mais: le modelé . . ."*[20] Rodin's hands were his principal tools, and with them he plopped and punched and gouged and smoothed, making both curves and straight lines wavy, allowing shoulders to flow into torsos and torsos to emerge from blocks (even when they hadn't), encouraging elbows to establish their own identity, his fingers everywhere busy at fostering the impression of life, giving strength and will to plaster, ethereality and spirit to stone.

Not to everybody's taste. Rodin's hopes for his work were revolutionary and, at first, few shared them. Lovers of the antique saw in the figure of Aphrodite the embodiment of Love. She was a god of mythology and therefore never existed, so she could only be regarded as ideal. Her thighs were to be as smooth as a peeled stick, though fleshier and amply curved. Since, like Hamlet or Jesus for that matter, no one knew what Love looked like, her form and all her emblems eventually achieved a generic status (Jesus is blond and thin, tall and handsome, not in the least Semitic); but this stereotype was never of a particular, an instance of which you might meet on the street, instead its entire being was devoted to the service of the universal. For fanciers of Christian figures,

[18] R.H. Wilenski. *The Meaning of Modern Sculpture.* Boston: Beacon Press, 1961, 25.
[19] See Albert Elsen's article, "Rodin's Perfect Collaborator, Henri Lebossé," in *Rodin Rediscovered,* edited by Albert Elsen for The National Gallery of Art. Washington, D.C., 1981, 249–259.
[20] Letter to Clara Rilke, September 5, 1902, op. cit., 84.

however, Mark and the other Testament teachers, while remaining within the type that had been cast for them, and representing the ideals of the religion as well as figures in Christian history, were nevertheless to be depicted as actual persons. Jesus may have been a scapegoat, but he must not be so idealized he becomes nothing but sacrifice. Another example: many sopranos must be able to play Mimi; if one of them cannot make Mimi's emaciated weight, then cast, crew, and customers will pretend they are watching the role sing rather than the occupant of it. Rodin's departures from these norms were felt before they were formulated. Where would we locate the walk of *The Walking Man?* in "walking itself"? in this sort of stride among many? in the habitual gait of someone exercising? and particularly during his morning constitutional? This amazing figure is the expression of a specific kind of muscular movement in which the determination of the walker's will, even without the walker, is evident in them. These legs walk by themselves. Across meadows. Down streets. Through walls. The battered torso is the handle of their fork.

> *The Walking Man* as finally exhibited is the antithesis of the nineteenth-century statue, for it lacks the old values of identity, assertive ego, moral message rhetorically communicated, completeness of parts and of finish, and stability. More than any other of Rodin's works, this sculpture overwhelms the viewer by the power of movement . . . No sculptor before Rodin had made such a basic, simple event as walking the exclusive focus of his art and raised it to the level of high drama.[21]

As Rodin's style developed so did the complaints. *The Age of Bronze* was felt to be so lifelike that it must have been made from a body cast. *The Walking Man* convicted the sculptor of dismemberment. *The Man with the Broken Nose, The Crouching Woman,* and *The Old Courtesan* were attacks upon their subjects, deliberately disgusting, or perverse attempts to make the ugly attractive. *The Kiss* was too sexy or too pretty, and *The Thinker* banal – or worse, a schoolboy bathroom joke. *The Gates of Hell* had ended up an expensive hodgepodge. *The Burghers of Calais* were too sorrowful, the monument didn't depict them as

[21] Elsen, op. cit., 32.

behaving bravely enough; although his model, *The Call to Arms,* proposed to commemorate the Franco-Prussian war, was so vehement it failed consideration. The great draped *Balzac* didn't look like Balzac, while the naked *Balzac* was an affront to the writer, his art, and his public. *Balzac,* in particular, called for outrage.

> He was accused variously of having depicted his subject as a penguin, a snowman, a sack of coal, a menhir, a phantom, a colossal fetus and a shapeless larva. Other criticisms included the charge that Balzac had been reduced to the role of an actor in a gigantic Guignol, that he had just gotten out of bed to confront a creditor, or that exposing the public to such maladroit handling of proportions and physical distortion was equivalent to the dangers of a live bomb.[22]

As late as 1932, R.H. Wilenski would claim, in his *The Meaning of Modern Sculpture,* that "Rodin's interest when he modelled the Balzac was concentrated in the head. Remove the head and we have nothing but a shapeless mess." Wilenski provides an illustration in which he has done the decapitation.[23]

It was claimed that Rodin's impressionistic style was better suited to painting than to sculpture, although the impressionists weren't initially approved of either; moreover, he appeared to disobey the modernist rule that the work should reflect the nature of its materials and manufacture, yet in what but clay would his kind of modulations occur? or his mingling of limbs be easy? This much was true: Rodin's aim was to transform his materials into something ontologically alive – after all had not God made mud into man?

Elie Faure enlists his eloquence, honed through a thousand pages of his *History of Art,* to register Rodin's errors.

> Often – too often, alas! – the gestures become contorted, the unhappy idea of going beyond plastics and of running after symbols creates groups in which the embracing figures are disjointed; the volumes fly out of their orbit, the attitudes are impossible, and, in the whole liter-

[22] Elsen, op. cit., 103.
[23] Wilenski, op. cit., 23, illus. 1b.

ary disorder, the energy of the workman melts like wax in the fire. Even in his best days, he lives and works by brief paroxysms, whose burning sensation runs through him in flashes.[24]

A good many of the misapprehensions that Rilke says constitute Rodin's fame were fomented by social scandals, as I have tried to suggest, and the sculptor's name continued to collect scurrilous rumors for the remainder of his life; but at the same time his renown drew to him many who were also famous, each bringing with them their own bounty of slander, gossip, and glorification. Isadora Duncan claims that she wants to have children of genius by him, and Loïe Fuller would love to wind multicolored ribbons round her body while he draws her.[25] Eleanora Duse will recite poetry at the Hôtel Biron, and Wanda Landowska play Bach upon a harpsichord trucked in for the occasion. Meanwhile the press enjoys publishing lampoons of various kinds, and caricatures by Sem and Belon amuse their publics. In one Rodin is depicted pulling the arms and legs off a female figure. I think we are to imagine she is not alive at the time. Another shows a garden of disembodied heads and embracing bodies called "Terrain Rodin."[26]

The Meudon days begin to pass. Rilke reads Rodin's press clippings in the villa's little park and enjoys the garden's postcard views, or he walks up the village slopes to a thick wood where he can brood in a solitude free of Paris's insistent presence or Rodin's impalpable one. Among his wishes: that he could take the forest's lofty fresh air back with him to the city where the heat is oppressive, the atmosphere odiferous, stale, and heavy. He presses his face against the fence of the Luxembourg Gardens like one in jail, and even the flowers in their beds feel constrained to be there.

On September 11 Rilke does something so transparent it almost ceases to

[24] Elie Faure. *History of Art – Modern Art*. Trans. by Walter Pach. New York: Harper and Bros., 1924, 402–3.
[25] Lest we forget Mrs. Fuller's talent, namely her skill with illusion, here is a juicy bit from Cocteau: "Is it possible . . . to forget that woman who discovered the dance of her age? A fat American, bespectacled and quite ugly, standing on a hanging platform, she manipulates waves of floating gauze with poles, and somber, active, invisible, like a hornet in a flower, churns about herself a protean orchid of light and material that swirls, rises, flares, roars, turns, floats, changes shape like clay in a potter's hands, twisted in the air under the emblem of the torch and headdress." Jean Cocteau. *Souvenir Portraits*. Trans. by Jesse Browner. New York: Paragon House, 1990, 81.
[26] Descharnes and Chabrun, op. cit., 216.

be devious. He writes Rodin a letter. Like a lover, he explains that his poor French makes it difficult for him to express himself as he would like, and the care with which he prepares his questions make them seem contrived and inappropriate for the occasion; so he is sending on a few verses in French with the hope that they will bring the two of them a little closer. After some customary fulsomeness, Rilke confesses that "It was not only to do a study that I came to be with you, – it was to ask you: how must one live?" The answer we've heard: *il faut travailler.* However, Rilke says he has always waited for the beckon of the muse, waited for what he calls the creative hour, waited for inspiration. He has tried to form habits of diligence but now he knows he must try again, try and succeed. Sadly . . .

> . . . last year we had rather serious financial worries, and they haven't yet been removed: but I think now that diligent work can disarm even the anxieties of poverty. My wife has to leave our little child, and yet she thinks more calmly and impartially of that necessity since I wrote her what you said: *"Travail et patience."* I am very happy that she will be near you, near your great work . . .
>
> I want to see if I can find a living in some form here in Paris, – (I need only a little for that). If it is possible, I shall stay. And it would be a great happiness for me. Otherwise, if I cannot succeed, I beg you to help my wife as you helped me by your work and by your word and by all the eternal forces of which you are the Master.[27]

The verses in French Rilke wrote for Rodin have a German brother, because on the same day, doubtless after the same stroll through the same park, he also penned one of the two better known autumn poems from *The Book of Hours.* His state of mind could not be better represented.

AUTUMN

The leaves are falling, falling from far away,
as though a distant garden died above us;
they fall, fall with denial in their wave.

[27] Letter to Auguste Rodin, September 11, 1902, op. cit., 87–88.

And through the night the hard earth falls
farther than the stars in solitude.

We all are falling. Here, this hand falls.
And see – there goes another. It's in us all.

And yet there's One whose gently holding hands
let this falling fall and never land.

Despite his misery, his anxiety, Rilke is greedily gathering material. These months will be among his richest. Incidents of no apparent moment will crystallize and coalesce. Here is one. At the end of September, he writes to Clara:

Rodin has a tiny plaster cast, a tiger (antique), in his studio . . . which he values very highly . . . And from this little plaster cast I saw what he means, what antiquity is and what links him to it. There, in this animal, is the same lively feeling in the modeling, this little thing (it is no higher than my hand is wide, and no longer than my hand) has hundreds of thousands of sides like a very big object, hundreds of thousands of sides which are all alive, animated, and different. And that in plaster! And with this the expression of the prowling stride is intensified to the highest degree, the powerful planting of the broad paws, and at the same time, that caution in which all strength is wrapped, that noiselessness . . .[28]

The panther Rilke will study in the Jardin des Plantes began to find its words, I suspect, as a tiny plaster tiger with a prowling stride and broad paws, the bars of his cage were borrowed from the Luxembourg Gardens, and his gaze from the poet's own, as well as his sense of desperation. The abbreviated sonnet, J.B. Leishman suggests, was the earliest of the famous *Dinge* or "thing" poems whose nature has been ascribed to Rilke's Rodin experience.[29]

[28] Letter to Clara Rilke, September 27, 1902, op. cit., 90. Rilke refers to the little tiger again in a letter to Lou Andreas-Salomé, August 15, 1903, 128.

[29] J.B. Leishman, editor and translator. *Rainer Maria Rilke – Selected Works, Vol. II: Poetry*. New York: New Directions, 1960, 178. These translations are from William H. Gass. *Reading Rilke*. New York: Alfred Knopf, 1999.

THE PANTHER

His gaze has grown so worn from the passing
of the bars that it sees nothing anymore.
There seem to be a thousand bars before him
and beyond that thousand nothing of the world.

The supple motion of his panther's stride,
as he pads through a tightening circle,
is like the dance of strength around a point
on which an equal will stands stupefied.

Only rarely is an opening in the eyes
enabled. Then an image brims
which slides the quiet tension of the limbs
until the heart, wherein it dies.

Rodin's surfaces are there to suggest a reality that can only be inferred, just as fingers or a face, by gesture or expression, disclose a consciousness that would otherwise be indiscernible. Sculptures are things: they start as stuff, stuff taken from stuff like rock or clay, and they stay stuff until the artist gives them a determinate form so that, through that form, they may have life. The poet's problem is precisely the opposite. Language is our most important sign of elevated awareness, but language has weak presence. Though often on paper, it possesses no weight. A poem is like a ghost seeking substantiality, a soul in search of a body more appealing than the bare bones mere verses rattle. It is consequently not the message in a bottle that Rilke previously thought it was, nor a young man's feelings raised like a flag. All of us have emotions urgently seeking release, and many of us have opinions we think would do the world some good, however the poet must also be a maker, as the Greeks maintained, and, like the sculptor, like every other artist, should aim at adding real beings to the world, beings fully realized, not just things like tools and haberdashery that nature has neglected to provide, or memos and laws that society produces in abundance, but *ding an sich,* as humans often fail to be, things-in-themselves. In a strange way, Rilke's new Rodin-induced resolve will unite the poet's most

primitive impulse – in this case, animism – with his most sophisticated inclination – art as an end, art that stands apart from nature and in opposition to it since nature does not and cannot produce it.

If we look at *She Who Was Once the Helmet-Maker's Wife* (sometimes called *The Old Courtesan*), we shall have to pass through several necessary shifts in point of view. The woman Rodin depicts is old, bent, clinging to a rock as if the river of life were about to sweep her away, skinny and scarred, all bone and tendon, her dugs pendulous, shrunken, and flat, her belly bunchy like a wrinkled bag; whereas once, we are asked to believe, her skin was smooth, her body lithe, strong, bearing breasts that were perfect bowls and boasting hair that fell across her back like lines of music; but the body's beauty, the sculpture unoriginally says, comes to this: the condition of the prune, a figure formed from suffering and age, alive only to wonder why.

Facile feelings of pity and regret are available from this site as stamps from a post office, yet what is piercing about the piece is its beauty, a beauty that we could sentimentalize by thinking, for a moment, that even decrepit whores in this wonderful world are lovely, when, of course, they are not, abuse takes its toll, hard living, too, and the body is our first grave. It is the bronze that is glorious; it is the bronze that reminds us that age and dying, death itself, has its own life, its own stages of fulfillment, its own value and measures of success. Baudelaire's poem, "A Carrion," for which Rodin and Rilke shared an admiration, is of the same genre as Villon's snows of yesteryear, Rochester's dust that has closed Helen's eyes, and Yorick's dug-up skull whose chaps are now quite fallen. It begins:

> Remember now, my Love, what piteous thing
> We saw on a summer's gracious day:
> By the roadside a hideous carrion, quivering
> On a clean bed of pebbly clay,
>
> Her legs flexed in the air like a courtesan,
> Burning and sweating venomously,
> Calmly exposed its belly, ironic and wan,
> Clamorous with foul ecstasy.

Rilke's animism is poetical, of course, but is also, in its way, religious, for it requires respect for all things equal to the respect we tend to show now for only a few, since we prize so little even in the things we prize. It gives value, as Rodin did, to every part of our anatomy, to each muscle movement – stretch, twitch and fidget; our physical features – a silk soft ear lobe, tawny limb or crooked finger; or facial expressions – grimace, smile or howl; as well as the very clay we come from (at least in his workshop) – wood block, slab, and plaster pot. Moreover, it endows even the accidental encounter of different parts – my hand on your shoulder – with its own dignity as a legitimate state of affairs. Gestures, expressions, postures, moods, thoughts, sudden urges merely change more rapidly than habits, attitudes, convictions, dispositions do, and can be slowed by stone to suit our scrutiny throughout a home-made eternity.

> The flies swarmed on the putrid vulva, then
> A black tumbling rout would seethe
> Of maggots, thick like a torrent in the glen,
> Over those rags that lived and seemed to breathe.[30]

It was not simply in the shop, among the fragments and the figures, that Rilke saw this willful independence and fullness of life. He encountered it on the streets of Paris. That thin pencil which rose slowly out of an old crone's fist was alive, as were the rusty pins that ran from side to side in their proffered drawer as if to escape your eye when you looked down on them. In the early morning the water from the water wagons "sprang young and light out of their pipes," the hoofs of the horses struck the street "like a hundred hammers," and the cries of the vendors echoed while "the vegetables on their handcarts were stirring like a little field." But his most indelible encounter was with the man suffering from St. Vitus Dance whose gyrations and frantic coping strategies he vividly describes in a letter to Lou Salomé (another rehearsal for passages that Rilke includes in *Malte Laurids Brigge*). Rilke follows the man for several blocks as the poor fellow's shoulders twitch, his arms fly about, and his legs jig.[31] The

[30] Allen Tate's wonderful translation. Charles Baudelaire. *The Flowers of Evil*. Selected and edited by Marthiel and Jackson Matthews. Norfolk, Conn.: New Directions, 1955, 38.
[31] Letter of July 18, 1903, op. cit., 112–115.

man's will is at odds with his limbs, each of which has its own plans, and all four would hop off by themselves if they had their way like the fragments in Rodin's cases.

So the surfaces of Rodin's work, which his studio light makes lively, implicitly rely upon a philosophical principle of great age and respectability – one that has been seriously entertained by Galileo, Hobbes, and Spinoza, through Freud up to the present. Since the effect in question is one of animation, it may seem odd that the principle involved is that of inertia. A body at rest will remain at rest – a body in motion will remain in motion – unless something else hectors or hinders it. When that interference occurs, the stone or the ball or the dog at the door will resist; it will attempt to restore the status quo, strive to save its situation, maintain its equilibrium, preserve its life. Spinoza called the tendency to stay the same the object's *conatus*. It is popularly thought of as the principle of self-preservation. All things would be self-sufficient, as windowless as Leibniz's monads, if they could. The condition of the fetus that is automatically fed, protected from every outside shock, surrounded by an embalming ocean, growing as it has been programmed to grow, is ideal. We are pushed out into the world; we are forced by circumstances both inside us (hunger and thirst), and outside (sensation and harm) to cope, and, as Freud argued, we are repeatedly compelled to reduce the unsettling demands of our desires to zero.

A limp that tells the world we are compensating for an injury becomes a habit hard to break even when its cause has healed and there is no longer any "reason" for it. Except that the limp wishes to remain. Our stutter wants to stay.

Our fall from a ladder would be forever like a cast-out angel if we didn't fetch up in a lake of fire or at least a floor. The fire, moreover, eats its way through every fuel it's offered only because it is eager to stay burning like that bright gem of quotation fame. As the naked models move about Rodin's studio, he observes the participating parts of their bodies until he can catch, in the middle of an action, the very will of the gesture, its own integrity and wholeness. The consciousness that inhabits us (and as Rilke likes to imagine inhabits even the so-called least thing) refuses to age. As we all have surely noticed, only our body gets old, and does so reluctantly, while each creak, each ache and

pain, comes to stay if it can, as vigorous as a virus, youthful as our death will be, buoyant and hopeful. Dying does not want to die. Dying would make dying a career. And death has its own designs.

We can call it war if we like – Hobbes did – we can call it competition, but unities create their own momentum, complex states of affairs resist disenabling influence (what are bureaucrats for?), and all of the figures that make up a sculpture like *The Burghers of Calais,* each eloquent in its own way, must feel the influence of so powerful a composition. The man with St. Vitus Dance had lost control of his Commonwealth. Which is what happens when parts of the body politic no longer feel safe to pursue their own plans and the grip of the state police grows weak. The group must ensure the safety of its members if it wishes to survive. Otherwise it will explode or choke itself to death. Similarly, the elements of a work of art must form a community which allows each element its own validity while pursuing the interest of the whole. A word, if it could have had a choice, must feel it would have chosen just the companions it has been given, so that when it glows with satisfaction it also makes its line shine.

Moreover, the unity of a sculptural fragment, when imagined alongside a correspondingly severed limb, insists upon its own superiority, for it can flourish quite apart from any body, whereas both amputation and amputee are damaged possibly beyond repair.

October was filled with Rilke's work on the essay, but now Clara had arrived in Paris and had her studio in the same apartment building as his, according to an arrangement he had finally worked out with his conscience. Their economic circumstances remained dire; the couple's dislike of Paris, now shared, increased; they endured their separate loneliness through the gray city's winter, living on roots and water, or so it seemed. The essay at last concluded, Rilke came down with the first of several bouts of flu and a gloom that obscured the upper half of the Eiffel Tower. By March he was ready to return to his itinerant ways, and fled for Italy, the first of many nations in which he would find refuge.

It would be three years to the month of his first meeting with Rodin before Rilke would return to Paris and Meudon, this time as an invited guest. The Master had read Rilke's monograph by this time, since it now extolled him in

French, and he welcomed the poet warmly as a trusted friend and fellow artist. The visitor was well-housed with a nice view of the valley. Rilke offered to help with some of Rodin's overwhelming paper work and was soon hired on, as it were, full-time. Often he, Rodin, and Rose Beuret would rise early to visit the city or enjoy Versailles, and once they dared Chartres in the dead of winter where terrible winds, because they were envious of such grandeur, Rodin said, tormented the towers.[32]

Rilke seeped into the role of Rodin's secretary, a position he wanted because it cushioned him in Meudon, because he was paid, because the work was expected to be undemanding; yet a position he did not want because it confined him to Meudon, his French might be inadequate, because it put him below stairs in Rodin's service when he had his own fish to hook and fry – the poet as ambitious as the sculptor.

Rilke planned a lecture tour on behalf of Rodin which would take him to Dresden late in October (the talk becomes Part II here), but the response to his first appearance disappointed him because, although there were "six hundred people," they were "not the right ones." Then in Prague he twice performed for a small crowd of mystified officials and sleepy old ladies whom he imagined were more concerned with the digestion of their dinners. When Rilke asks, a few paragraphs into his text, "Are you listening?" is the question entirely rhetorical? Worse than their inattention, his take wasn't covering costs. In Berlin there were visits and readings before he repeated his Rodin lecture a final time – on this occasion with some success.[33]

Spring of 1906 would find him back in Meudon where his work, fatter than he remembered, sat upon his shoes like a heavy dog. In one of his poems he likened himself to a swan out of water, waddling his way "through things still undone." The personal epistle was an art form at which Rilke excelled, but the business letter in French was boring, intractable, foreign, and frustrating. The poet had become dilatory and the sculptor impatient. Moreover, Rilke had begun answering mail without taking the trouble to inform Rodin of the fact or the nature of the exchange, assuming an authority he did not have: once to

[32] Some details from Ruth Butler's *Rodin: the Shape of Genius*. New Haven: Yale University Press, 1993.
[33] Freedman, op. cit., 233, 242.

Baron Heinrich Thyssen-Bornemisza, a wealthy German patron, once to Sir William Rothenstein, an important English art administrator and academic painter. Upon learning of these presumptions, Rodin fired Rilke with a force that expelled him from his cottage and the grounds as well as from his secretarial position. He was soon back in his little Paris room, a spent shell.[34]

The poet had recovered his perilous freedom, his personal space, a space, one suspects, that was very like the space he believed Rodin's figures required, not only one which allowed you to inspect them "in the round," but a space that was theirs by right of uniqueness, that distinguished them somehow "from the other things, the ordinary things, which anyone could grasp." A small statue could, therefore, seem large. Rilke, too, required such room as respect conferred, where he might stand "solitary and luminous" with "the face of a visionary." Yet Rilke's rhetoric, when he writes about Rodin's work, is not simply a reflection of his need to enhance his own importance, it also expresses the necessity for any work of art to lay claim to the appropriate arena of its enjoyment, hence the close placement of paintings in some museums above below or beside one another on the same wall or the squeezing of a bust into a corner or the dumping of a figure at the end of a narrow hall that leads to the johns, the elevators, or the shops is either a sign of catastrophic overcrowding, a show of curatorial contempt, or evidence of feeble artistic force. Even a fragment should stand in its space like Napoleon, and there is ample testimony to the imperial effect of Rodin's sculptures whatever their size. In his essay collection, *Leonardo's Nephew,* James Fenton quotes Aristide Maillol – as his talk is recollected by the ubiquitous Count Kessler:

> When you view a Rodin from afar, it's small, very small. But sculpture forms part of the air all around it. Rodin has a Buddha at his place, well placed on a socle, in his garden, in front of a circle of small shrubs. Well, its as big as that [showing it very small] and yet it's as big as the sky. It's immense. It fills everything.[35]

[34] Ibid., 245.

[35] James Fenton. *Leonardo's Nephew.* New York: Farrar, Straus & Giroux, 171. *Berlin in Lights: the Diaries of Count Harry Kessler.* New York: Grove Press, 1999 is an abridgement of the diaries and does not contain this quote so don't hunt for it there nor in the corresponding English edition.

Rilke was similarly taken with this piece.

BUDDHA

As if he listened. Silence. Depth
And we hold back our breath. Yet nothing yet.
And he is star. And other great stars ring him,
though we cannot see that far.

O he is fat. Do we suppose
he'll see us? He has need of that?
Sink in any supplicating pose before him,
he'll sit deep and idle as a cat.

For that which lures us to his feet
has circled in him now a million years.
He has forgotten all we must endure,
encloses all we would escape.

Rodin's American biographer, Ruth Butler, suggests that some additional factors were at work in Rilke's dismissal. When Rilke returned from his leisurely lecture tour, Rodin was ill with what was called the grippe. Rose Beuret was in a foul mood which didn't improve his. So he asked George Bernard Shaw, whose bust he had been commissioned to sculpt, if he and his wife would take the train to Meudon to sit for it so that the ailing artist wouldn't have to come to his workshop in Paris. At first the Shaws came unencumbered, but when Shaw learned that Rodin didn't mind being photographed (the playwright had tried his own hand), he asked permission for his friend, the American photographer, Alvin Langdon Coburn, to visit as well. Shaw, not easily impressed by anyone farther from himself than his beard, was aware that Rodin's thumb was a greater imprimatur than the Pope's seal, and told Coburn: "No photograph taken has touched him . . . He is by a million chalks the biggest man you ever saw; all your other sitters are only fit to make gelatin to emulsify for his negative."[36] Even more frequently photographed were Rodin's sculptures, of

[36] Details of this meeting from Butler, op. cit., 390, and the quote from *Alvin Langdon Coburn: Photographer, An Autobiography*. New York: Dover Publications, 1978, 22.

course, many of the better ones the work of Eugène Druet. These Rodin some-
times stage managed, but few of them (Edward Steichen's) possess the esthetic
quality or inherent drama of Michael Eastman's contemporary images which
are as assuredly at home in this volume with Rilke's rich text as any could be.[37]
Rodin could not have been disappointed with Coburn's customarily lyrical
view since it shows the sculptor wearing a beard like a river and a hat we now
call a "pillbox." There is a slight upward tilt to Rodin's head that resembles the
heroic pose he fashioned for Balzac.

To watch Shaw pose for his immortality Shaw gathered a crowd, also call-
ing the curator of the Fitzwilliam Museum, Sydney Cockerell, to his side.

Rilke joined them, almost immediately impressed with Shaw as a sitter –
the entire squad eager to write brilliantly about a glittering constellation they
underestimated even while trying to exaggerate it.

In the newspaper *Gil Blas* for May 24th, 1912, Shaw recollected the occasion:

> Rodin worked laboriously . . . When he was uncertain he measured me
> with an old iron compass and then measured the bust. If the nose was
> too long he cut off a section and pressed the end to close the wound
> with no more emotion or affectation than a glazier replacing a window.
> If the ear was not in its place he would cut it off and lay it on correctly,
> these mutilations being executed cold-bloodedly in the presence of my
> wife (who almost expected to see the already terribly animated clay
> begin to bleed) while remarking that it was quicker to do it thusly than
> to make a new ear.[38]

Rilke wrote to Shaw's German publisher, Samuel Fischer:

> Rodin has begun the portrait of one of your most remarkable authors;
> it promises to be exceptionally good. Rarely has a likeness in the mak-
> ing had so much help from the subject of it as this bust of Bernard
> Shaw's. It is not only that he is excellent at standing (putting so much
> energy into standing still and giving himself so unconditionally to the

[37] For Rodin's relationship to this art see Kirk Varnedoe's article, "Rodin and Photography" in *Rodin Rediscovered,* op. cit., 203–248.
[38] Quoted by Elsen, op. cit., 126.

sculptor's hands), but he so collects and concentrates himself in that part of the body which, in the bust, will have . . . to represent the whole Shaw, that his whole personality seems to become concentrated essence.[39]

They all took a break to attend the celebration for the installation of *The Thinker* in front of the Panthéon. Shaw, not to be outdone (and as excellent at sitting as standing), persuaded Coburn to photograph him the very next day, naked following his morning bath, in the pose presently before the Panthéon. The photo exists for posterity's wonder. Rilke was visibly taken with the English genius, who didn't mind adulation even from callow unknowns. Apart from that, during Rodin's week of work, and worse, during his week of triumph, Shaw had clearly been competing for attention if not glory with a sundry that included Rodin's secretary and Rodin's statue. Butler says: "It was Rilke who paid the price for the mischievous Englishman's visit."[40]

Although Rilke would suggest to Rodin the purchase of the Hotel Biron, later the Rodin Museum, and for a time live in that building (as Cocteau would, who claimed to have a role in its preservation), his intimacy with Rodin was over. Two days after Shaw's departure for London, on May 10th, 1906, Rilke was "dismissed like a thieving servant." We can pretend to know precisely.

William H. Gass

[39] Quoted by Butler, op. cit., 390–391.
[40] Ibid., 191.

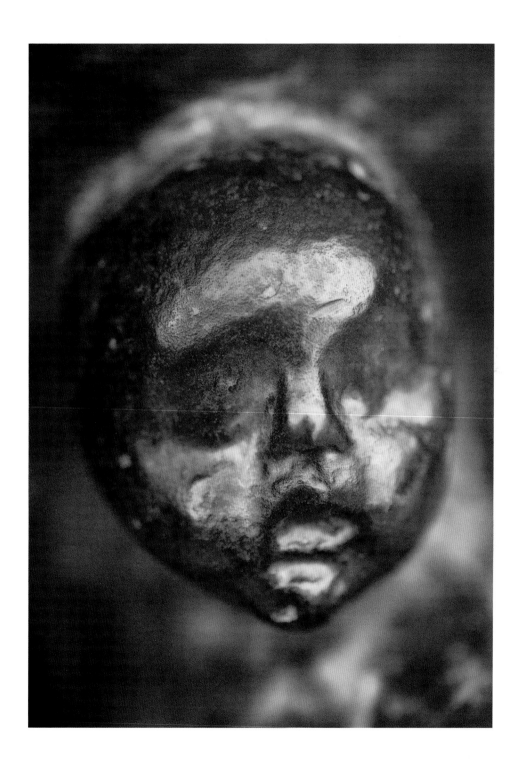

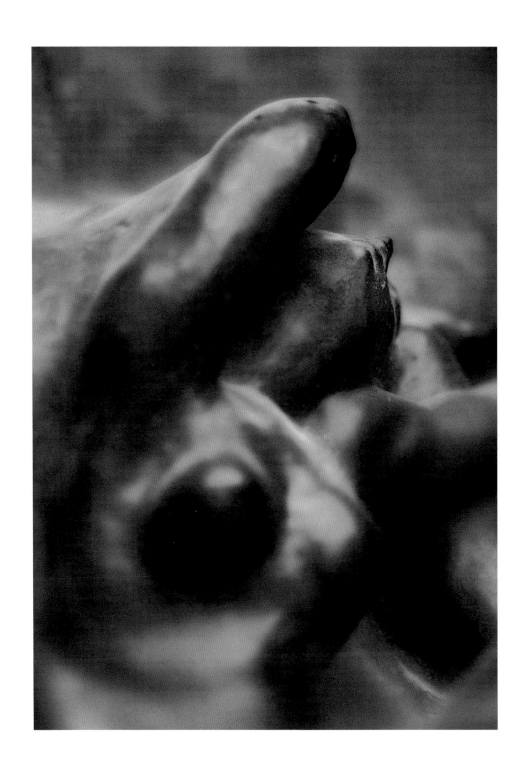

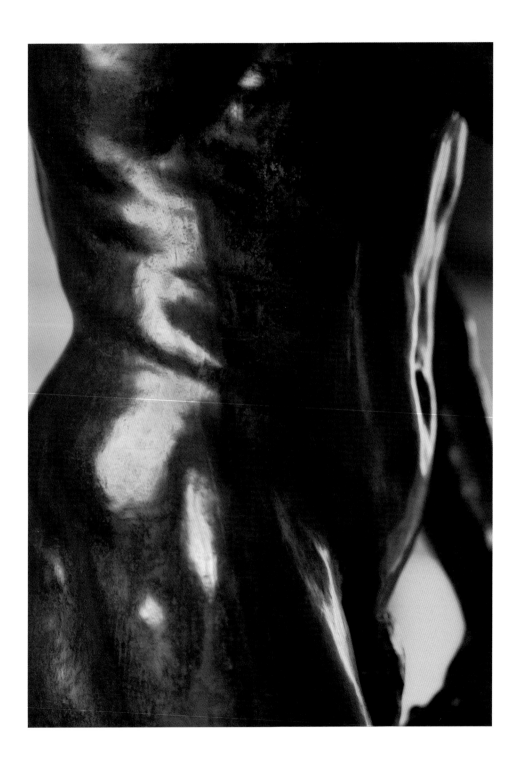

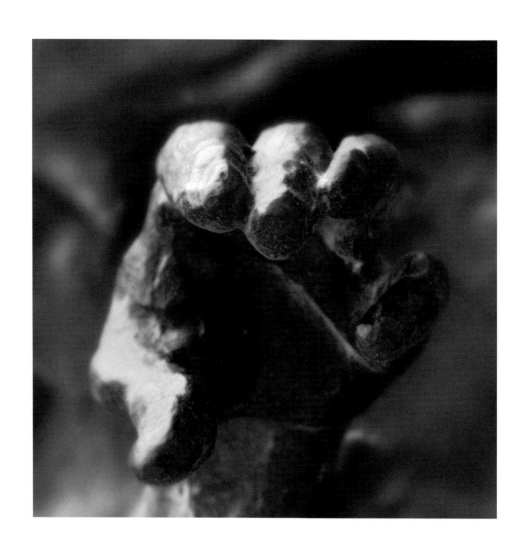

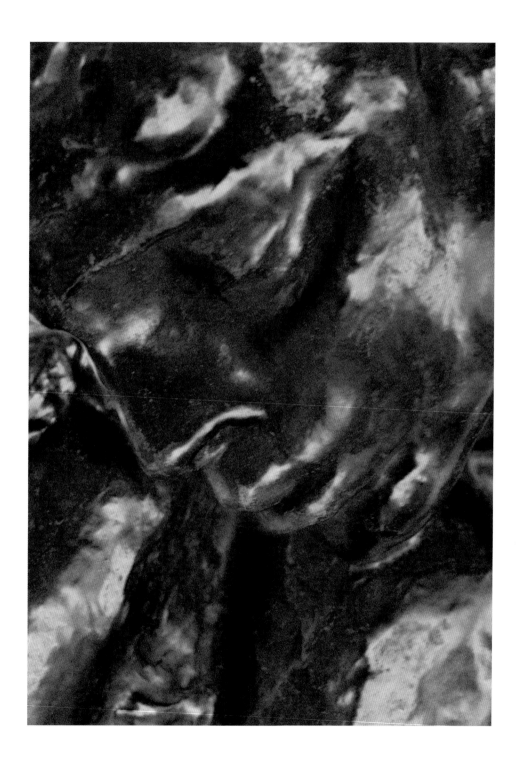

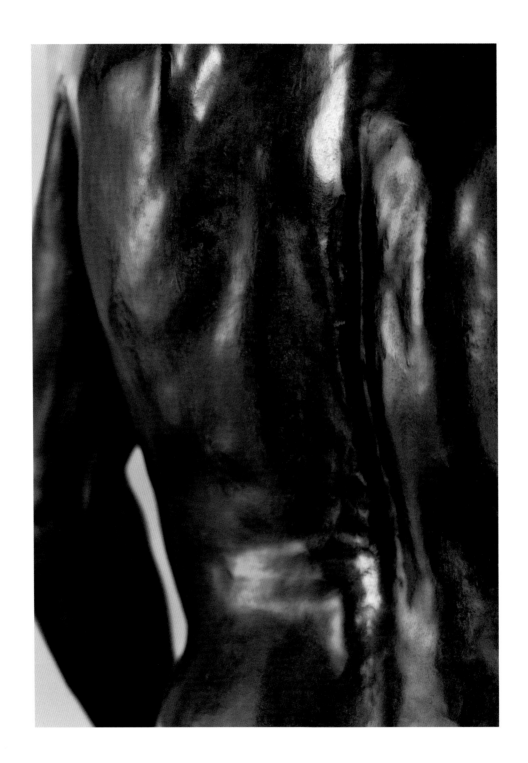

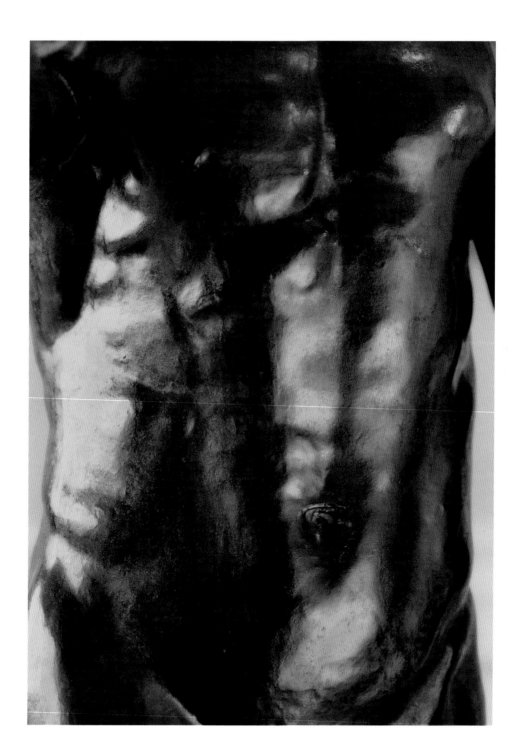

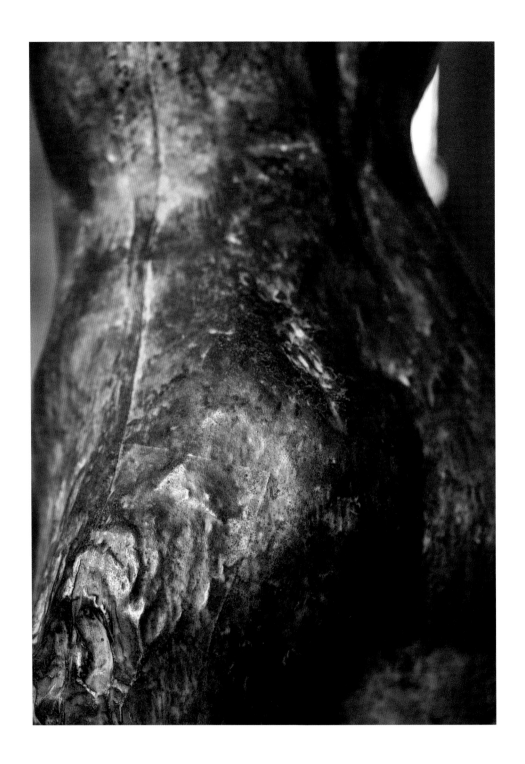

Auguste Rodin

WRITERS WORK WITH WORDS,

SCULPTORS WITH ACTIONS.

Pomponius Gauricus,
"De Sculptura" (circa 1504)

THE HERO IS HE WHO

IS IMMOVABLY CENTERED.

Emerson

PART I (1902)

RODIN WAS SOLITARY BEFORE HE
was famous. And fame, when it arrived, made him perhaps even more solitary.
For in the end fame is no more than the sum of all the misunderstandings that
gather around a new name.

There are many of these around Rodin, and clarifying them would be a
long, arduous, and ultimately unnecessary task. They surround the name, but
not the work, which far exceeds the resonance of the name, and which has
become nameless, as a great plain is nameless, or a sea, which may bear a name
in maps, in books, and among people, but which is in reality just vastness,
movement, and depth.

The work of which we speak here has been growing for years. It grows
every day like a forest, never losing an hour. Passing among its countless mani-
festations, we are overcome by the richness of discovery and invention, and we
can't help but marvel at the pair of hands from which this world has grown. We
remember how small human hands are, how quickly they tire and how little
time is given them to create. We long to see these hands, which have lived the
life of hundreds of hands, of a nation of hands that rose before dawn to brave
the long path of this work. We wonder whose hands these are. Who is this man?

He is an old man. And his life is one of those that resists being made into a
story. This life began and now it proceeds, passing deep into a venerable age; it

almost seems to us as if this life had passed hundreds of years ago. We know nothing of it. There must have been some kind of childhood, a childhood in poverty; dark, searching, uncertain. And perhaps this childhood still belongs to this life. After all, as Saint Augustine once said, where can it have gone? It may yet have all its past hours, the hours of anticipation and of desolation, the hours of despair and the long hours of need. This is a life that has lost nothing, that has forgotten nothing, a life that amasses even as it passes. Perhaps. In truth we know nothing of this life. We feel certain, however, that it must be so, for only a life like this could produce such richness and abundance. Only a life in which everything is present and alive, in which nothing is lost to the past, can remain young and strong, and rise again and again to create great works. The time may come when this life will have a story, a narrative with burdens, episodes, and details. They will all be invented. Someone will tell of a child who often forgot to eat because it seemed more important to carve things in wood with a dull knife. They will find some encounter in the boy's early days that seemed to promise future greatness, one of those retrospective prophecies that are so common and touching. It may well be the words a monk is said to have spoken to the young Michel Colombe almost five hundred years ago: *"Travaille, petit, regarde tout ton saoul et le clocher à jour de Saint-Pol, et les belles oeuvres des compaignons, regarde, aime le bon Dieu, et tu auras la grâce des grandes choses."* "And the grace of great things shall be given to you." Perhaps intuition spoke to the young man at one of the crossroads in his early days, and in infinitely more melodious tones than would have come from the mouth of a monk. For it was just this that he was after: the grace of great things. There was the Louvre with its many luminous objects of antiquity, evoking southerly skies and the nearness of the sea. And behind it rose heavy things of stone, traces of inconceivable cultures enduring into epochs still to come. This stone was asleep, and one had the sense that it would awake at a kind of Last Judgment. There was stone that seemed in no way mortal, and other stone that seemed in motion, gestures that remained entirely fresh, as if they were preserved here only to be given one day to a passing child. And this vitality was not limited to the famous works, to those visible to all. The unseen, small, nameless, and seemingly superfluous works were no less filled with this deep inner force, with this rich and astonish-

ing disquiet of life. Even the stillness, where there was stillness, consisted of hundreds of motive moments held in equilibrium. There were small figures, especially animals, moving, stretching, or crouching, and even when a bird sat still, one knew very well that it was a bird, for the sky issued forth and surrounded it, a breadth was apparent in the smallest folds of its wings, which could spread to astonishing size. And the same thing was true of the animals that stood and sat on the cathedrals, or crouched beneath the consoles, bent and bowed and too inert to bear weight. There were dogs and squirrels, sparrows and lizards, turtles, rats, and snakes. At least one of every kind. These creatures appeared to have been captured out in the forests and on the paths, as if the strain of living among shoots, flowers, and leaves of stone had transformed them slowly into what they were now and would always remain. But there were also animals that were born into this world of stone, without any memory of another existence. They had always been entirely at home in this upright, towering, precipitous world. Skeletons arched up among these fanatically lean creatures. Their mouths opened wide with cries of the deaf, for the nearby bells had destroyed their hearing. Some crouched like birds upon the balustrades, as if they were passing through and simply wanted to rest for a few centuries, staring down at the growing city. Others, descended from dogs, thrust horizontally from the edge of the spouting into the air, prepared to spit water from swollen maws. All these creatures had adapted and changed, but they lost none of their vitality in the process. To the contrary, they lived more vigorously and more violently, they lived eternally the fervent and impetuous life of the time that had given rise to them.

Seeing this picture, one sensed that these creatures had not resulted from whim, or from a merely playful attempt to find new, unusual forms. They were born of necessity. Fearful of the invisible judgment of a severe faith, their creators had sought refuge in these visible forms, fleeing from uncertainty to this materialization. Still seeking the face of God, these artists no longer attempted to demonstrate their piety by creating in his vastly distant image, but rather by bringing all their fear and poverty into his house, by placing all their modesty and humble gestures in his hands and upon his heart. This was better than painting, for painting too was an illusion, a beautiful and cunning

deception. They longed for something more significant, something simpler. And so the strange sculpture of cathedrals came about, this sacred procession of the beasts of burden.

When we look back from the sculpture of the Middle Ages to antiquity, and from there to the beginnings of time, does it not seem as if the human soul has always longed, and particularly at turning points both light and distressing, for an art that gives more than word and picture, more than parables and appearance; for the simple realization of its desires or anxieties in things? The last great age for sculpture was the Renaissance. It was a time when life was undergoing renewal, when the mysterious face of mankind was discovered anew, a time when great gestures were possible.

And now? Is it possible that another age demanding this form of expression had arrived, an age demanding a strong and perceptive interpretation of that which defied articulation, of that which was confused and enigmatic? The arts did seem to be undergoing a kind of renewal, animated by great excitement and expectation. Perhaps it was just this art, this sculpture that still lingers in the shadows of its great past, which was called on to discover what the others were longing and groping for? Surely this art could come to the aid of an age tormented by conflicts that were almost all invisible. Its language was the body, but when had this body last been seen? It was buried under layer upon layer of garb, renewed perpetually by the latest styles. But beneath this protective crust, the ripening soul was changing the body, even as it was working breathlessly on the human face. The body has been transformed. If we were to uncover it now, it would probably have a thousand expressions for everything nameless and new that had come into being in the meantime, for those old secrets that emerge from the unconscious like strange river gods, raising their dripping heads from the rush of blood. This body would be no less beautiful than that of antiquity. Indeed, it could only be even more beautiful. For life has held it in its hands two millennia longer, working on it, listening to it, and hammering at it day and night. Painters dreamed of this body, they adorned it with light and infused it with twilight. They approached it with tenderness and charms of every kind, they stroked it like the petal of a flower and let them-

selves be carried along in it like a wave. But sculpture, to which the body belonged, did not know it yet.

Here was a task great as the world. And the man to whom it was given was unknown, his hands searching blindly for bread. He was completely alone, and if he had been a proper dreamer, he would have dreamed deeply and beautifully, he would have dreamed something no one would understand, one of those endlessly long dreams in which life passes like a day. But this young man, who was working in a factory in Sèvres at the time, was a dreamer whose dream got into his hands, and he began immediately with its realization. He had a sense for how to begin; a calmness within showed him the way of wisdom. His deep harmony with nature was evident already at this stage, the harmony described so well by the poet Georges Rodenbach, who calls Rodin simply a force of nature. In fact, Rodin is possessed of a patience so deep it almost makes him anonymous; a quiet, considered serenity reminiscent of the patience and goodness of nature, which begins with next to nothing only to traverse the long path to abundance in silent solemnity. In the same way, Rodin was not presumptuous enough to create trees. He began with the seed, underground as it were. And this seed grew downward, sinking its roots into the earth, anchoring itself before the first small shoot began to rise up. This took time and then more time. And when the few friends around him pushed and prodded, Rodin would say, "One must never hurry."

Then came the Franco-Prussian war and Rodin went to Brussels, where he worked on what the days brought to him. He designed some figures for private houses and several of the groups on the stock exchange building, and then he created the four large figures on the corners of the monument to Mayor Loos in the Parc d'Anvers. He carried out these commissions conscientiously, without permitting any expression of his growing individuality. His own development proceeded alongside this work, relegated to breaks and evenings, and sustained primarily in the solitary stillness of the nights. He endured this division of his energy for years. He possessed the strength of those upon whom some great work is waiting, the silent endurance of those the world needs.

While he was working on the stock exchange in Brussels, he must have felt

that there were no longer buildings which were up to bearing works of stone like the cathedrals had been, those great magnets of the sculpture of the past. Works of sculpture now stood alone, just as paintings stood alone; but unlike pictures created on easels, a sculpture did not require a wall. It didn't even require a roof. It was simply a thing that could stand on its own, and it was good to provide it with the essence of a thing, which one could walk around and view from all sides. And yet it had to be distinguished somehow from the other things, the ordinary things, which anyone could grasp. It had to become somehow untouchable, sacrosanct, removed from the influence of chance and time, in the context of which it stands solitary and luminous, like the face of a visionary. It required a secure place of its own, selected in the most mindful way, for it must be made part of the subtle permanence of space and its great laws. It must be fitted into the air that surrounds it like a niche, providing it with security and stability, and with a sublimity that comes from its simple existence, not from its significance.

Rodin knew well that the most essential element of this work was a thorough understanding of the human body. He explored its surface, searching slowly, until a hand stretched out to meet him, and the form of this outward gesture both determined and was expressive of forces within the body. The further he went on this distant path, the more chance receded, and one law led to another. And in the end this surface became the subject of his study. It consisted of infinite encounters between things and light, and it quickly became clear that each of these encounters was different and all were remarkable. At one point the light seemed to be absorbed, at another light and thing seemed to greet each other cautiously, and then again the two would pass like strangers. There were encounters that seemed endless, and others in which nothing seemed to happen, but there was never one without life and movement.

It was then that Rodin discovered the fundamental element of his art and, as it were, the germ of his world. This was the plane – the variously large and accentuated, but always exactly determined plane – from which everything would be made. From this moment on, the plane was the material of his art, the source of all his efforts, vigilance, and passion. His art was not based on a great idea, but rather on the strength of a humble, conscientious realization,

on something attainable, on ability. There was no arrogance in him. He devoted himself to this unassuming and difficult beauty, to that which he could survey, summon, and judge. The rest, the greatness, would have to come only when everything was finished, just as animals come down to drink when the night is full and there are no longer strange things in the forest.

Rodin's most distinctive work began with this discovery. It was only then that traditional notions of sculpture became worthless for him. There was no longer any pose, group, or composition. Now there was only an endless variety of living planes, there was only life and the means of expression he would find to take him to its source. Now it became a matter of mastering life in all its fullness. Rodin seized upon life as he saw it all around him. He observed it, cleaved to it, and laid hold of its most seemingly minor manifestations. He watched for it at moments of transition and hesitation, he overtook it in flight, and everywhere he found it equally great, equally powerful and enthralling. No part of the body was insignificant or trivial, for even the smallest of them was alive. Life, which appeared on faces with the clarity of a dial, easily read and full of signs of the times, was greater and more diffuse in bodies, more mysterious and eternal. Here there was no deception. Here indifference appeared as such, and pride was simply pride. Stepping back from the stage provided by the face, the body removed its mask and revealed itself as it really was behind the curtains of costumes. It was here that he found the spirit of his age, just as he had discovered the spirit of the Middle Ages in its cathedrals: gathered around a mysterious darkness, held together by an organism, adapting to it and in its service. Human beings had become temples, and there were tens of thousands of these temples, none of them identical and all very much alive. And the most important thing was to demonstrate that they were all of one God.

Rodin followed the paths of this life year after year, a humble pilgrim who never stopped thinking of himself as a beginner. No one knew of his travails; he had few friends and even fewer he could trust. Sheltered behind the efforts that sustained him, the work continued to grow, awaiting its time. He read widely. He was often to be seen on the streets of Brussels reading a book, yet we can't help but wonder if these books were but a pretext for a deep absorption in himself, in the unfathomable task before him. As with all who are called

to action, this sense of the enormity of the work ahead provided incentive, heightening and concentrating his powers. And when doubt and uncertainty appeared, when impatience with that which was coming into being threatened, when the fear of an early death crept in, or the hardships of daily existence, they were always met by a quiet, resolute resistance, by defiance, strength, and confidence, by all the flags that would be unfurled in the victory yet to come. Perhaps the past took his side in those hours; the voice of the cathedrals, which he never stopped listening to. From books, too, came considerable support. Reading Dante's *Divine Comedy* for the first time was a great revelation. He saw the suffering bodies of another generation. He saw, across the span of countless days, a century stripped of its clothes, and he recognized the poet's great and unforgettable judgment on his age. They were images that only confirmed his own sensibility, for when he read of the weeping feet of Nicholas the Third, he already knew that feet could weep; indeed, he knew that there is a kind of weeping that encompasses the whole body, and that tears can come from all the pores.

From Dante he came to Baudelaire. This was no tribunal of judgment, no poet ascending on the hand of a shadow to heaven. Here, rather, was a simple human being, a mere mortal who suffered like everyone, lifting his voice high above the din, as if to save us all from destruction. And there were sections of these lyrics that stood out from the rest, passages that seemed to be formed more than written, words and groups of words that were molded in the hot hands of the poet, lines like reliefs to the touch, and sonnets like columns with twisted capitals, bearing the weight of troubled thoughts. He felt dimly that the abrupt ruptures of this art ran up against the beginnings of another art, and that it longed for this other art. He came to think of Baudelaire as a predecessor, an artist who refused to be led astray by faces but sought bodies instead, in which life was greater, more gruesome and more restless.

From this time forward, these two poets were always close to him. His thoughts reached out beyond them but always returned. In that seminal, formative period of his art, when the life it was learning was still nameless and without significance, Rodin's thoughts roamed in the books of these poets, and he found in them a past. Later he would draw again on this rich material as a

source for his own creative art. Figures would arise, weary and entirely real, like memories from his own life, making their way into his work as if they were coming home.

Finally, after years of solitary work, he surfaced with one of his works. It was a question put to the public, and the public responded negatively. So Rodin withdrew within himself for another thirteen years. These were the years in which, still toiling in obscurity, he developed into a master, gaining complete command of his medium, constantly working, thinking, and experimenting, uninfluenced by his time, which took no notice of him. Perhaps it was just this – that his whole development had proceeded in such undisturbed serenity – that would give him such tremendous confidence later, when he was attacked, and when his work became the object of no small criticism. When others began to doubt him, he no longer had any doubt in himself. All that was behind him. His fate no longer depended on the recognition and acclaim of the public; it was already decided by the time people tried to annihilate him with hostility and disdain. Rodin was immune to the voices of the outside world in the time of his becoming. There was no praise that could have led him astray, no censure that might have confused him. Like Parsifal, his work grew in purity, alone with itself and with great, eternal nature. His work alone spoke to him. It spoke to him in the morning when he awoke, and reverberated like an instrument in his hands late into the evening. His work was invincible because it came into the world mature. It no longer appeared as something that was coming into being and thus seeking justification; rather, it was as if reality had emerged, and one simply had to reckon with it. Like a king who learns of plans for a city to be built in his realm, considers whether to grant the privilege, hesitates, and then finally decides to check the prospective site only to discover that the city is already complete, its walls, towers, and gates standing as if from eternity, people came when they were finally summoned, and found Rodin's work complete.

Two works mark this period of growing maturity. At the beginning stands the head of *L'Homme au nez cassé,* at the end the figure Rodin called *First Man. The Man with the Broken Nose* was rejected by the Salon in 1864. This is not difficult to imagine, for one can't help but feel that with this work, entirely whole

and sure as it was, Rodin had already reached full maturity. With the forth-rightness of a great confession, it violated the precepts of academic beauty that were still predominant at the time. Rude had given the wild gesture and wide-mouthed scream to his Goddess of Revolt on the triumphal arch in the Place de l'Etoile in vain; Barye, too, had created his graceful animals in vain; and Carpeaux's *Dance* was greeted with scorn, until familiarity eventually made it impossible to see it for what it was. Nothing had changed. In those days sculpture was still models, poses, and allegory – the simple, facile, and leisurely work that consists essentially of more or less accomplished variations on a few sanctioned gestures. In this environment the head of *The Man with the Broken Nose* almost surely would have caused a storm much like the one that broke only when Rodin's later works appeared. But it seems more likely that, because it was the work of an unknown artist, it was rejected summarily.

We feel what moved Rodin to form this head, which is that of an aging, ugly man, whose broken nose only heightens the pained expression on his face. The fullness of life is gathered in these features, and there are absolutely no symmetrical planes on the face. Nothing is repeated, no spot remains empty, mute, or neutral. Life had not simply touched this face, it had shaped it through and through, as if an inexorable hand had thrust it into destiny and held it there, in the rush and swirl of cleansing waters. Holding this mask and turning it slowly, one can't help but be astonished by the constantly changing profiles, none of which are in any way uncertain, incidental, or indefinite. On this head there is not a single line, angle, or contour that Rodin hadn't seen and intended. We get the sense that some of these furrows appeared earlier and others later, that years – difficult years – lay between the gashes across the features. We know that some of the marks on this face were etched slowly, with great hesitation, and that others were traced lightly at first, only to be inscribed more deeply by habit or a recurring thought. And we recognize those sharp incisions that can only have resulted from a single night, hacked as if by the beak of a bird in the weary brow of one starved for sleep. The life emanating from this work is so weighty and nameless, and we struggle to remember that all this appears in the shape of a face.

Placing the mask before us, it is as if we were standing on an enormous

tower, looking down on an uneven landscape, surveying the winding paths crossed by countless people over the years. Picking it up again, we hold a thing that can only be called beautiful on account of its perfection. But its beauty is not solely a result of the incomparable meticulousness with which it was crafted. It comes, rather, from the sense of proportion, the balance of the living planes, and from an understanding of the fact that all these moments of ferment come to rest within the thing itself. And while one can't help but be moved by the protean pain of this face, one also has the unmistakable sense that it utters no accusation. It makes no appeal to the world. It seems to carry its own justice within, the reconciliation of all its contradictions, and a patience sufficient for the weight of its burden.

A man sat motionless before Rodin when he created this mask, his expression calm and unmoved. But it was the countenance of a living person, and as he studied this face it became clear that it was full of motion, full of disquiet and crashing waves. There was movement in the course of the lines and in the grade of the planes. The shadows played as if in sleep, and light passed softly over the brow. There was, in short, no peace, not even in death. For even in decline, which is also motion, death was subordinate to life. There was always motion in nature, and art that wished to present a conscientious and faithful interpretation of nature could not idealize a motionlessness that exists nowhere. In reality there was no such ideal in antiquity. We have only to think of Nike. This sculpture gives us more than the motion of a lovely young woman going to meet her lover; it is also an eternal representation of the wind of Greece, of its breadth and glory. Even the stones of ancient cultures were not still. The restlessness of living surfaces was inscribed in the restrained, hieratic gestures of ancient cults, like water within the walls of a vessel. Currents flowed through gods at rest, and those who stood seemed to embody motion, like a fountain rising from the stone and then falling back again, covering it with innumerable waves. Motion was never at odds with the spirit of sculpture (which means simply the essence of things); it was only motion that remained incomplete, motion that was not in balance with other forces, motion that extended beyond the boundaries of the thing. Works of sculpture resemble those ancient cities where life was passed entirely within the city walls: the

people did not lack for air and their gestures never became cramped. But nothing went outside the limits of the circle enclosing them. There was no sense of what was beyond, nothing to indicate a life beyond the gates, and no sense of expectation opening without. No matter how great the motion in a work of sculpture may be, and whether it comes from infinite expanses or the depths of the heavens, it must always return to itself. The great circle of solitude in which the art object passes its days must be closed. This was the unwritten law that lived in the sculpture of the past, and Rodin understood it. This distinguishing characteristic of things – this complete self-absorption – was what gave sculpture its serenity; it could neither demand nor expect anything from outside itself, and it could refer to nothing and see nothing that was not within itself. Its surroundings had to be found within it. It was the sculptor Leonardo who gave this unapproachability to *La Gioconda,* this motion inward, this gaze one cannot meet. His *Francesco Sforza* probably had the same quality, this expression of motion in return, like a proud ambassador who returns to his country after the fulfillment of some great purpose.

In the long years that passed between the mask of *L'Homme au nez cassé* and the figure of *First Man,* Rodin developed in many quiet ways. New associations linked him more closely with the tradition of his art. This past and its greatness, which so many before him had felt to be a burden, lent wings to Rodin, carrying him aloft. For when he sensed confirmation in those years, affirmation of what he wanted and was searching for, it came from the art of antiquity and from the furrowed darkness of cathedrals. Living human beings didn't speak to him in those years. Stones spoke.

If *L'Homme au nez cassé* had demonstrated Rodin's profound understanding of the human face, the *First Man* manifested his complete mastery of the body. *"Souverain tailleur d'ymaiges"* – that title used selflessly by the masters of the Middle Ages to appraise one another's work – now came to him. Life was not simply great all over this life-size nude figure, it was endowed everywhere with the same sublimity of expression. What appeared on the face – the pain of a difficult awakening along with the longing for this hardship – was written as well on the smallest feature of its body. Every part was a mouth giving voice to it in some way. The most exacting eye could not discover any part of this figure that

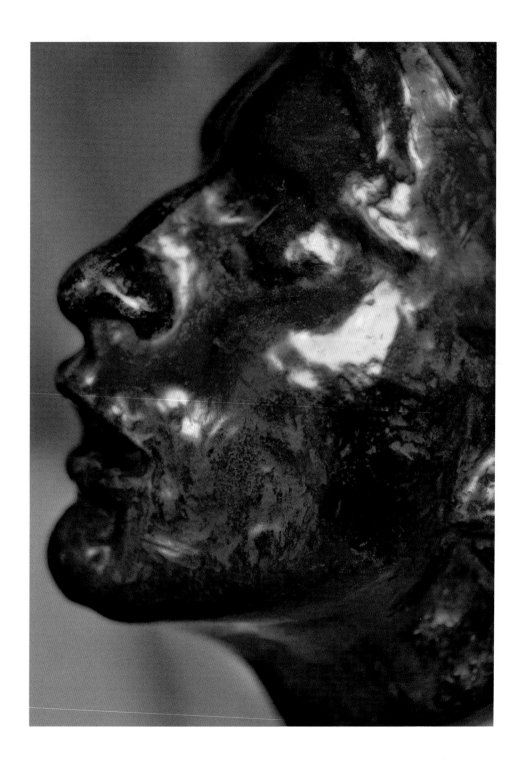

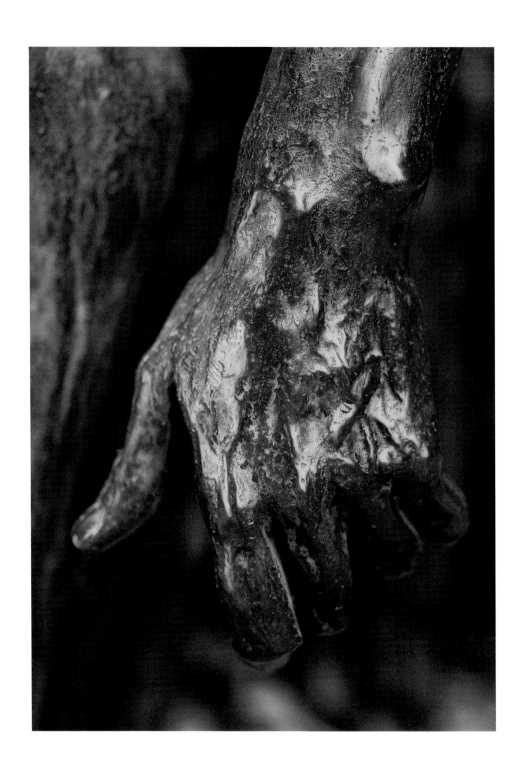

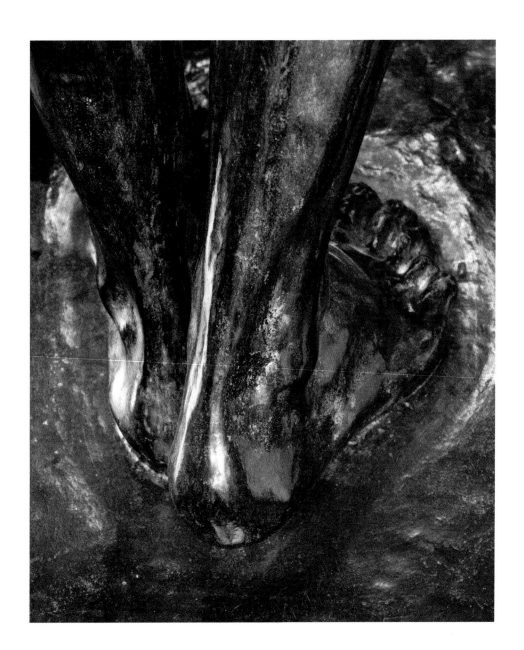

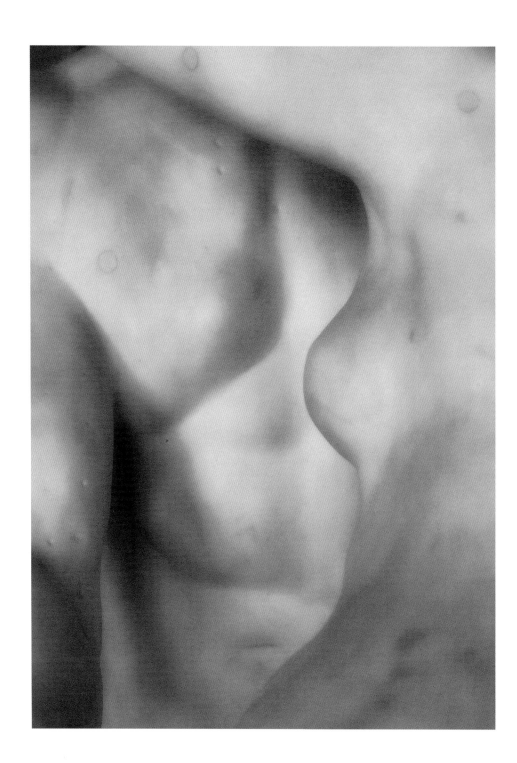

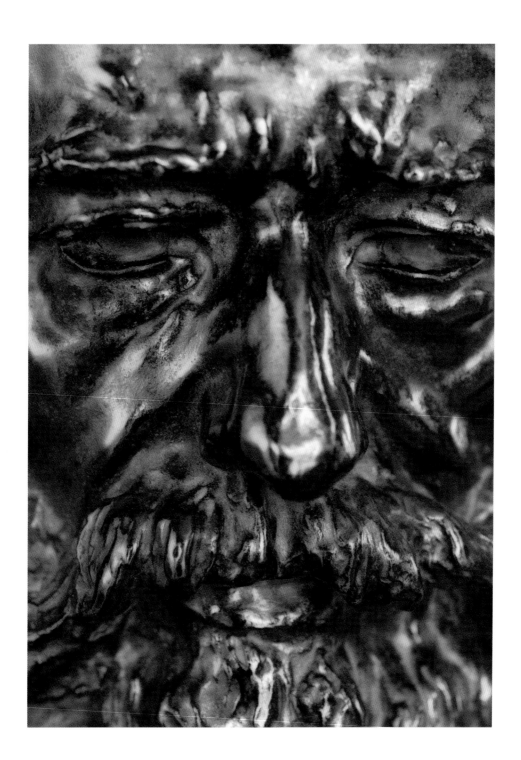

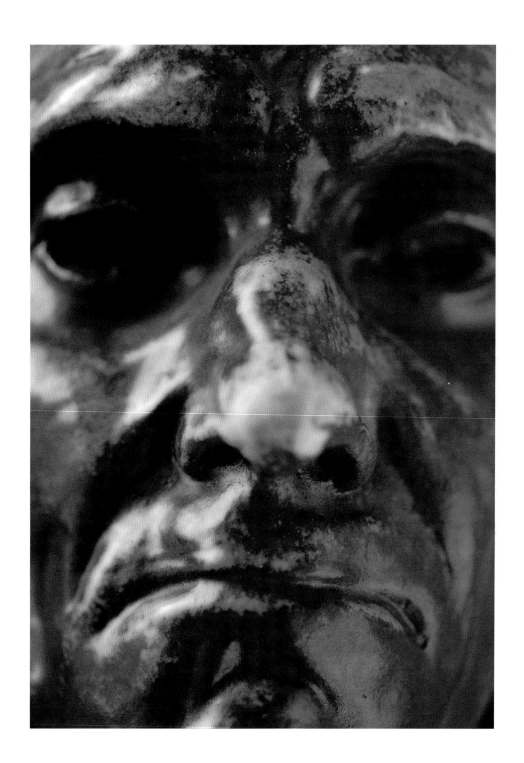

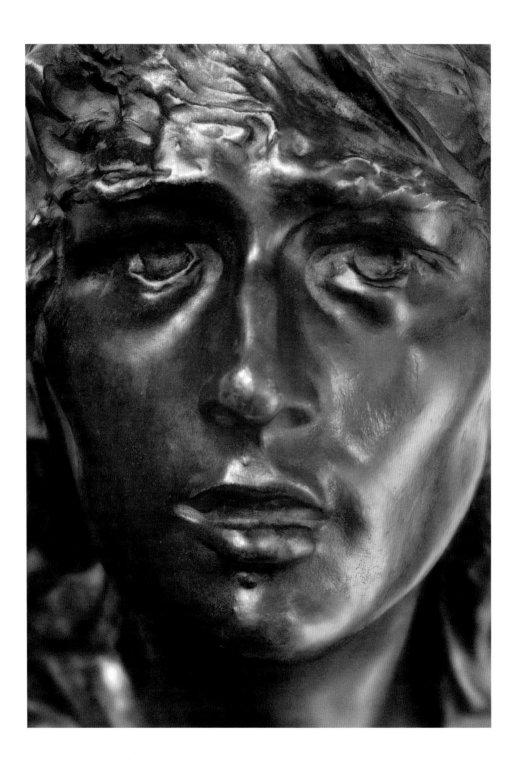

could be identified as less alive, less determined and clear. It was as if strength surged up from the depths of the earth to fill the veins of this man. He was like the silhouette of a tree facing spring storms, fearful because the fruit and fullness of its summer no longer lives in the roots, but rather is rising slowly, up through the trunk buffeted by great winds.

This figure is significant in another sense as well. It marks the birth of gesture in the work of Rodin. This gesture, which would grow and develop with such force and proportion, came forth here like the waters of a spring, running down softly over the body. It awoke in the darkness of earliest times, and seems, as it grows, to run through the breadth of this work as it does through the ages, and to pass far beyond to those who will come. It appears tentatively in the raised arms, arms so heavy that one of the hands comes to rest on the crown of the head. But this hand is not asleep; it is gathering strength. High up on the solitary peak of the brain, it prepares itself for work – for the work of centuries, which has no limit or end. And in the right foot the first step waits.

We might describe this gesture as one of the repose enclosed in a hard bud. Embers of thoughts and a storm of the will: it opens and *John* comes out, with those eloquent, agitated arms, and the great bearing of one who feels another coming up from behind. The body of this man is no longer untested: the deserts have scorched him, hunger has racked him, and thirst has sapped his strength. He has come through it all and is hardened. His lean, ascetic body is like a wooden handle, holding the wide fork of his stride. He walks. He walks as if the whole wide world were in him, as if he were apportioning it as he walks. He walks. His arms speak of this walking, and his fingers stretch out, a sign of his stride in the air.

This *John* is the first walker in Rodin's work, but many more would follow. There are *The Burghers of Calais* setting out on their arduous journey, and all his walkers seem to prepare the way for the great challenging stride of *Balzac*.

But the gestures of standing are developed further as well. The figures withdraw within themselves, curling up like burning paper, growing stronger, more concentrated and vital. Exemplary of this is the figure of *Eve*, which was originally intended to stand above *The Gates of Hell*. Her head is sunk deep in the darkness of her arms, which are folded across her chest as if she were freez-

ing. The back is rounded, the neck almost horizontal, and she leans forward as if to listen to her own body, in which a strange future is beginning to stir. It is almost as if the weight of the future burdens this woman's senses, drawing her down from the abstractness of life and into the deep humble service of motherhood.

Rodin returns again and again in his nude figures to this turn inward, to this intense listening to one's own depths. We see it in the extraordinary figure he called *La Méditation,* and in the unforgettable *Voix intérieure,* the softest voice of Victor Hugo's songs, which is almost concealed by the voice of anger in the monument to the poet. Never before has the human body been so concentrated around its interior, so shaped by its own soul and yet restrained by the elastic power of its blood. And the way the neck rises ever so slightly, stretching to hold the listening head above the distant rush of life, is so impressive and deeply felt that one has a difficult time remembering a gesture as moving or expressive. The arms are noticeably missing. In this case Rodin must have felt them to be too easy a solution to his problem, something not belonging to a body that wished to remain shrouded in itself, without any help from outside. One thinks of how Duse, left painfully alone in one of D'Annunzio's plays, tried to embrace without arms and to hold without hands. This scene, in which her body learned a caress that extended far beyond itself, belongs to the unforgettable moments of her acting career. It conveyed the sense that arms are superfluous, merely decorative effects common among the rich and excessive, which one could cast off in order to be completely poor. At that moment one did not have the sense that she had forfeited something important; rather, she was like someone who has given her cup away in order to drink from the stream, like someone who is naked and still a bit awkward with the depth of the revelation. The same thing is true of Rodin's armless statues: nothing essential is missing. Standing before them, one has the sense of a profound wholeness, a completeness that allows for no addition. The notion that they are somehow unfinished does not result from simple observation, but rather from tedious consideration, from the petty pedantry dictating that arms belong to a body, and thus that a body without arms can never be whole. Not long ago people objected to the way the Impressionists cut trees off at the

edges of paintings, but we quickly adjusted to that. We learned – at least in the world of painting – to see and believe that an artistic whole doesn't necessarily coincide with the ordinary whole-thing, and that, apart from their agreement, new unities come about, new associations and relations, new equilibriums. It is no different in sculpture. The artist's task consists of making one thing of many, and a world from the smallest part of a thing. In Rodin's work there are hands, independent little hands, which are alive without belonging to any single body. There are hands that rise up, irritable and angry, and hands whose five bristling fingers seem to bark like the five false heads of Cerberus. There are hands that walk, hands that sleep and hands that wake; criminal hands weighted with the past, and hands that are tired and want nothing more, hands that lie down in a corner like sick animals who know no one can help them. But then hands are a complicated organism, a delta in which life from the most distant sources flows together, surging into the great current of action. Hands have stories; they even have their own culture and their own particular beauty. We grant them the right to have their own development, their own wishes, feelings, moods, and occupations. Rodin knows by way of the training he took upon himself that the body consists solely of scenes of life, a life that can become great and individual in any place, and he has the power to provide any part of this broad, variegated plane with the autonomy and richness of a whole. Just as the human body is a whole for Rodin only insofar as all its limbs and powers respond to one common (inner or outer) movement, so do the parts of various bodies come together of inner necessity to make up a single organism. A hand lying on the shoulder or thigh of another body no longer belongs completely to the one it came from: a new thing arises out of it and the object it touches or grasps, a thing that has no name and belongs to no one, and it is this new thing, which has its own definite boundaries, that matters from that point on. This vision provides the basis for the grouping of figures in Rodin; from it comes that unprecedented interconnectedness of the figures, that inseparability of the forms, that not letting go, not at any price. He doesn't set out to create figures, and there are no models to be shaped and put together. He begins with places where the contact is strongest, and these are the high points of the work. He sets in there, where something new is coming about, dedicat-

ing the vast knowledge of his craft to the mysterious appearances that accompany the becoming of a new thing. He works by the light of flashes that occur at these points, seeing only those parts of the whole body that are illuminated in the process. The magic of that great pairing of a young woman and a man called *The Kiss* lies in this wise and eminently fair distribution of life. In observing this work, one almost can sense that waves pass into the bodies from the various points of contact on the surface, showers of beauty, intuition, and power. It is this that accounts for how we feel we can see the ecstasy of this kiss in every part of these bodies; it is like a rising sun, casting its light everywhere. But there is another kiss that is even more wonderful – the kiss around which the piece called *The Eternal Idol* rises like walls around a garden. One of the copies of this marble piece belonged to Eugène Carrières. In the quiet twilight of his home this luminous stone lived like a spring, enlivened by an unchanging motion, always the same rise and fall of magical powers. A girl kneels. Her lovely body leans back gently. Her right arm stretches back, and her searching hand has found her foot. These three lines, from which no path leads out into the world, enclose her entire life and all its mystery. The stone beneath elevates her even as she kneels. And suddenly we recognize in the bearing of this girl, in the lethargy, reverie, or solitude into which she has fallen, the sacred gesture of a primeval goddess from a distant, terrible cult. The woman's head leans forward slightly. With an expression of tenderness, nobility, and patience, she looks down as if from the height of a silent night, down at the man whose face is buried in her breasts as if in myriad blossoms. He too kneels, but more deeply, deep in the stone. His hands lie behind him like worthless, empty things. The right hand is open, letting us look in. A mysterious greatness emanates from this group. As is so often the case with Rodin, one hardly dares ascribe meaning to it. There are thousands. Thoughts pass over this sculpture like shadows, and in the wake of each of them it rises new and enigmatic, lucid and nameless.

Something of the mood of a Purgatory lives in this work. A heaven is near, but not yet attained; a hell is near, and not yet forgotten. And here too, all this radiance comes from the contact of two bodies, and from the contact of the woman with herself.

The colossal *Gates of Hell,* which Rodin worked on for twenty solitary years

and which has yet to be cast, is still another rendering of this great theme: the contact of living, moving planes. Proceeding with the exploration of the movement and the union of these planes at one and the same time, Rodin searched for bodies touching at many places, bodies whose contacts were more intense, stronger, and less restrained. The more points of contact there were for two bodies, the more impatiently they came together like chemicals of great affinity, and the more stable and organic was the new whole they made together. Memories of Dante appeared. Ugolino and the pilgrims themselves. Dante and Virgil come together. The throng of the voluptuous, above which the greedy gesture of avarice loomed like a withering tree. Centaurs, giants, and monsters rose up before him, along with fauns and their consorts, and all the savage god-beasts of the pre-Christian forest. And he created. He realized all the figures and forms of Dante's dream, lifting them up from the moving depths of his own memory and giving to each in turn the faint redemption of material existence. Hundreds of figures and groups came about in this way. But the movements he discovered in the words of the poet belonged to a different time. They awoke in the artist who brought them to life the knowledge of thousands of other gestures, gestures of accumulation, loss, suffering, and resignation, and all those gestures that had evolved in the meantime. His tireless hands went on and on, beyond the world of the Florentine poet, to ever new gestures and figures.

This earnest, focused worker, who had never searched for material and who desired no achievement beyond what his increasingly mature art might bring, passed in this way through all the dramas of life: deep nights of love were revealed to him in all their profundity, that space of darkness, lust, and sorrow in which, as in an enduring heroic world, clothing was unknown, faces were extinguished, and bodies came into their own. He came to the great confusion of this struggle with white hot senses, as a seeker of life, and what he saw was just that: Life. It didn't close in on him, petty and oppressive. It spread out, leaving the cramped atmosphere of the alcoves far behind. Here was life, a thousand-fold in every moment, in longing and sorrow, in madness and fear, in loss and gain. Here was a boundless desire, a thirst so great that it dried up all the water in the world to a single drop. Here there were no denials or lies, and

as for the gestures of giving and taking, here they were honest and great. There was vice and depravity, damnation and bliss alike, and one understood suddenly that a world which concealed and covered this, a world which acted as if it were otherwise, could only be poor. But it was not otherwise. This other story ran alongside the whole history of humanity. It knew no disguise or convention, and paid no heed to rank or class. It knew only struggle. This other story had its own development as well. Instinct had become longing, and the desire of men and women for each other had become the passion of human relations. And this is the way it appears in the work of Rodin. There is still the eternal battle of the sexes, but here the woman is no longer an animal who submits or is overpowered. She too is awake and animated by desire, as if they had both joined forces to search for their souls. The man rising to quietly seek another in the night is like a treasure hunter who hopes to uncover the great happiness that is so necessary at the crossroads of sex. And in all this vice, in all the unnatural lust, in all the desperate and doomed attempts to ascribe an eternal meaning to existence, there is something of the inexplicable longing that animates great poets. The hunger of humanity extends beyond itself here, and hands reach for eternity. Eyes open, looking death in the face without any fear. A hopeless heroism develops here too, whose glory comes and goes like a smile, like a rose that blossoms and withers. Here are the storms of desire and the calm of expectation; here are the dreams that become actions, and the actions that fade into dreams. Power is won and lost here as if on an enormous gaming table. All this can be found in Rodin's work. It was here that this man who had experienced so much would discover the richness and abundance of life. Bodies whose every part was will, and mouths taking on the form of cries that seemed to rise from the bowels of the earth. He found the gestures of primitive gods, the beauty and grace of the animals, the intoxication of ancient dances, and the motions of forgotten religious rites, all of it strangely linked together with the new gestures that had come about in the long years since art turned away, blind to all these revelations. He found these new gestures particularly interesting. They were impatient. Like a man who searches widely for some object, becoming more and more desperate, distracted, and hurried, wreaking destruction all around him, accumulating things as if he could force them to join in his search,

but sowing disorder in the process – these are the gestures of a humanity that can not find meaning, a humanity that has become more impatient and nervous, more frantic and feverish. All the questions of existence lie unsettled around these gestures. But at the same time their movements have become more hesitant. They no longer have the gymnastic and decisive directness with which our predecessors grasped for everything. They don't resemble those movements preserved in ancient sculptures, those gestures whose births and deaths were everything. Countless transitions had intruded between these two simple moments, and it soon became clear that modern life, in its actions and in its inability to act, was to be found precisely in these intermediary states. Grasping had become different, as had waving, releasing, and holding. They all were possessed of much more experience, but also much more ignorance; much more cowardice and a constant assault on objects; much more regret for what had been lost, much more calculation, judgment, and reflection, and at the same time less spontaneity. Rodin created these gestures. He made them from one or many forms, shaping them into things in his way. There were hundreds and hundreds of these figures, many just slightly larger than his hands, to carry the life of all the passions, the blossoming of all lust and the burden of all burdens. He created bodies that touch everywhere, clinging together fiercely like dogs in a death grip, falling as one thing into the depths. There are bodies that listen like faces and bodies that hold up like arms, chains of bodies, garlands, and tendrils, and figures like grapes, heavy with the sweetness of sin rising from the roots of pain. Leonardo fused human beings together with similar force and majesty in his grandiose representation of the end of the world. Here as there we find figures hurling themselves into the abyss in the hope of escaping great misery, and others crushing the heads of their children to prevent them from growing into the pain.

The army of these figures had become far too prodigious for all to fit into the frame and wings of *The Gates of Hell*. Rodin made a number of selections. He excluded everything that was too solitary to submit to the great totality, everything that wasn't entirely necessary in this context. He let the figures and groups find their own places; he observed the life of the people he had created, listening and letting them all act according to their own will. This is the way the

world of these *Gates* gradually came about. Its surfaces, to which the sculpted forms would be attached, began to come to life. The agitation of the figures melted into the surface in reliefs of decreasing depth. Within the frame there is an upward motion from both sides, a pulling- and lifting-up, while the dominant motion on the wings of the gate is a falling glide and rush. The wings recede slightly, their upper border separated from the protruding edge of the cross frame by a rather large surface. In front of this, set within the enclosed stillness of the space, is the figure of *Le Penseur,* the man who sees the enormity and vast horror of the scene because he thinks it. He sits in mute absorption, heavy with pictures and thoughts, and all his strength (which is the strength of a man of action) goes into this thinking. His whole body has become a skull, all the blood in his veins a brain. He is the center of this Gate, although there are three more male figures standing above him on top of the frame. Because of the depth or the gate, they seem to emerge from a great distance. Their heads bow together and three arms stretch forward, coming together and pointing down to the same spot, into the same abyss, which draws them down with its weight. *The Thinker,* on the other hand, must bear this weight within.

Many of the groups and sculptures to which these *Gates* gave rise are strikingly beautiful. It is impossible to enumerate them all, just as it is impossible to describe them. Rodin himself once said that he would have to talk for a year to repeat a single one of his works with words. But perhaps it is enough to say that like the small animal figures left by antiquity, Rodin's little sculptures of plaster, bronze, and stone give the unmistakable impression of great things. In Rodin's studio there is a small Greek cast of a panther (the original is in the medallion case in the Bibliothèque Nationale in Paris). Looking under its body, into the space formed by four lithe legs, one almost has the sense of looking into the depths of an Indian rock temple. In this way Rodin's work expands to great proportions. The same thing is true of his little sculptures. In giving them so many layers, so infinitely many complete and perfectly defined planes, he makes them great. The air wafts around them as it does around rocks. Where there is upward motion the sky rises with them, and the flight of their fall brings the stars down as well.

It may well be that *The Danaid,* that figure flinging herself from a kneeling

position into her flowing hair, belongs to the same period. Walking slowly around this piece of marble is an extraordinary experience: the long, long way around the rich curve of the back, to the face losing itself in the stone as if in a great weeping, to the hand like a last flower, speaking softly of life deep in the eternal ice of the block. And *The Illusion, the Sister of Icarus,* that dazzling embodiment of a long, helpless fall. And the magnificent group called *L'Homme et sa pensée.* If we were to interpret this representation of a man who kneels and awakens with a mere touch of his forehead the soft form of a woman still bound to the stone, we would have to begin with the expression of indivisibility with which thought clings to the man's brow: for in the end it is only his thought that takes on life before him, and right behind it is stone. The head, too, is related to this, rising silent and meditative from the great block of stone on which the chin rests – the *thought,* this piece of clarity, being, and face that rises slowly from the heavy sleep of enduring staleness. And then there is the *Caryatid.* This is no longer an upright figure bearing the burden of a stone with ease or great difficulty, as if she had taken her position only after the stone was fixed. This is the nude figure of woman, kneeling, bent over, compressed within herself and formed completely by the hand of a burden whose weight sinks into all her limbs like a perpetual fall. The stone rests on even the smallest part of this body like a will that is greater than it, older and more powerful, yet the body is fated eternally to carry the weight. It bears this burden as we bear the impossible in dreams, finding no way out. There is bearing even in the deflatedness and palpable failure of this body, and when exhaustion overtakes it again, forcing it to recline, there will be bearing even in its reclining, the bearing of a burden without end. This is the *Caryatid.* If we wished to do so, we could associate most of Rodin's works with ideas, explaining and encompassing them. There are those for whom simple contemplation is an unusual and difficult path to beauty, and for them there are other ways, detours leading to meanings: noble, great, and fully formed. It is as if the infinite goodness and truth of all these figures – the perfect balance of all their movements, the wonderful inner justice of their proportions, their being-imbued-with-life – as if all that makes them beautiful endows them as well with the power to be inimitable realizations of the material the master drew upon when he named them. With Rodin

the material is never bound to the art object like an animal in a tree. It lives somewhere near the thing; it lives from it, like the custodian of a museum. Much is to be learned by calling on Rodin's people, but if we can do without their knowledge and observe the work alone and undisturbed, we experience even more.

Where the first impulse came from some material, where the source of inspiration was an ancient legend, part of a poem, a historical scene, or some actual person, once Rodin begins to work on this material, it is transformed progressively into something objective and nameless. Translated into the language of the hands, the resulting demands all have new meaning, which could only be realized in stone.

This process of forgetting and transforming the original material is often anticipated by Rodin's drawings. He developed his own means of expression in this medium as well, and it is this that makes these sketches (there are several hundred of them) independent and original revelations of his individuality.

There are watercolors with astonishingly strong effects of light and shadow from this early period. The famous *L'Homme au taureau,* so reminiscent of Rembrandt, is an excellent example, as are the head of the young John the Baptist and the shrieking mask of the Genius of War; they all can be seen as studies that helped the artist recognize the life of planes and their relation to the atmosphere. Then there are figures drawn with a hunted certainty, forms filled out in all their contours, shaped with many quick pencil strokes, and others enclosed in the melody of a single vibrating outline, from which rises a gesture of unforgettable purity. Typical of these are the drawings Rodin made to illustrate *Les Fleurs du Mal* for a tasteful collector. We say nothing when we speak of his profound understanding of Baudelaire's poetry, but we begin to say more when we recall how the perfect completion of these poems allows for no addition, no heightening of effect. And yet we feel both enhancement and heightening when we see how Rodin's lines complement the work. This is a fine indication of the enchanting beauty of these drawings. The sketch placed beside the poem titled "La mort des pauvres" extends beyond these great verses with a gesture of such simple and flourishing greatness that it seems to fill the whole world from dawn to dusk.

The same is true of the dry-point etchings; here the course of infinitely delicate lines gives the appearance of the outer contour of a beautiful glass object, which, defined clearly at any given moment, flows beyond the essence of a reality.

And finally there are those strange documents of the momentary, those chronicles of all that is imperceptibly transitory. Rodin assumed that if a model's most inconspicuous and unassuming movements were captured quickly, they would provide an unfamiliar intensity of expression, because we are not accustomed to observing them with keen, active attentiveness. Never losing sight of his model and leaving the paper entirely to his quick, experienced hand, he drew a vast number of gestures that are rarely seen and almost always neglected. The strength of expression emanating from them was prodigious; movements were linked in ways that had been overlooked and unrecognized, and they had all the directness, strength, and warmth of pure animal life. A brush of ochre, passed quickly and with varying emphasis through these contours, modeled the enclosed surface with such unbelievable force that the plastic figures looked to be created of baked clay. Once again, a whole new world had been discovered, filled with nameless life, and the depths over which all others had passed yielded its waters to he who had prophesied with the willow rod.

This practice of rendering the subject first in drawings was also an important part of the preparations with which Rodin proceeded slowly and carefully to the portraits. For while it surely is inappropriate to see a form of Impressionism in his sculpture, the abundance of impressions, and the way they are collected with such precision and boldness, does provide him with a wealth of material from which he selects what is important and essential, only to unite it all in a mature synthesis. Moving from the bodies, which he researches and forms, to the faces, it must have sometimes seemed as if he were stepping from a windy, momentous expanse into a room filled with people: here everything is crowded and dark, and the mood of an interior reigns beneath the arching brows and in the shadow of the mouth. While there is always change and the rhythm of waves in Rodin's bodies, a constant ebb and flow, the faces evoke the air. They are like rooms where much has happened, where there has been joy

and fear, sorrow and hope. None of these experiences is gone entirely; one does not replace another, but each takes its place among the others, remaining to fade like a flower in water. And he who comes from outside, from the great wind, brings breadth into the room.

The mask of *L'Homme au nez cassé* was the first portrait Rodin created. His distinct way of encountering a face is already fully developed in this early work. We sense his unbounded devotion to what was before him, his reverence for every line drawn by fate, his trust in life, which creates even where it disfigures. He created *The Man with the Broken Nose* with a kind of blind faith, without asking who the man was, this man whose life passed again in his hands. He made him just as God made the first man, without intending to produce anything but life itself, nameless life. But he would return to the faces of humanity, always more knowledgeable, more experienced, more magnanimous. He could no longer see their features without thinking of the days that had worked on them, of that great army of craftsmen constantly at work on a face, as if it could never be finished. In this way the quietly conscientious reproduction of life became for the mature artist – initially hesitant and experimental, then increasingly certain and bold – an interpretation of the script that covered these faces. He gave no play to his imagination, and invented nothing. Not for a moment did he disdain the difficult development of his craft. It would have been easy to ascend somehow and surpass it. As always, he kept step beside it, going the requisite distance, like the farmer behind his plow. But while he made his furrows, he reflected on the profundity of the land and the sky above it, on the passage of the winds and the falling rains, on everything that was and did harm and passed and returned, and on all that would not cease to be. And now, stronger and less confused by the multiplicity, he felt himself capable of recognizing the eternal in all this, that which made suffering also good, that which made expectation of hard times, and beauty of pain.

This vision, which began with the portraits, grew deeper and deeper into his work. It is the last stage, the outer circle of his vast development. It began slowly. Rodin walked this new path with infinite caution. Again he proceeded from plane to plane, following and listening to nature. It was nature itself that

showed him the places he knew more about than met the eye. When he went to work and created a great simplification from many small details in disarray, the result resembled what Christ had done when people approached him with unclear questions and he cleansed them of their sins with a sublime parable. He fulfilled nature's own intentions. He completed things that were helpless in their becoming, and he revealed hidden relationships just as the evening of a hazy day reveals mountains extending into the distance like rolling waves.

Filled with the animating burden of his vast knowledge, he looked like a seer into the faces of those living around him. This gives an extraordinarily precise clarity to his portraits, but also that prophetic greatness that rises to an indescribable perfection in the images of Victor Hugo and Balzac. For Rodin, creating a portrait meant searching for eternity in any given face, that piece of eternity with which it took part in the great life of eternal things. Just as we hold a thing up to the sky in order to understand its form more purely and simply, these images are all moved, if ever so slightly, from their moorings into the future. This is not what is commonly called beautification, nor would it be accurate to speak of giving something characteristic expression. It is more a matter of separating the enduring from the transitory, passing judgment, being just.

Apart from the etchings, Rodin's work includes a vast number of perfect and masterly portraits. There are busts made of plaster, bronze, marble, and sandstone, heads of baked clay and masks that were simply left to dry. There are portraits of women from all the periods of his work. The famous bust in the Luxembourg Museum is one of the earliest. She is filled with an uncommonly beautiful life and possessed of a distinctly feminine charm, but many later works surpass her in the simplicity and concentration of their planes. This is perhaps the only one of Rodin's works that does not owe its beauty primarily to the virtues of its sculptor; for this portrait also lives in part from the spirit of a grace that has characterized French sculpture for centuries. This piece is distinguished vaguely by the elegance that marks even bad sculpture in the French tradition; it isn't entirely free of that gallant representation of the *belle femme,* which was soon left behind by Rodin's assiduousness and incisiveness. But we would do well to remember that this inherited sensibility was also to be over-

come; he had to suppress an innate facility in order to begin anew as a pauper. Not that he needed to stop being French; after all, the great masters of the cathedrals were French as well.

The later images of women have a different, more deeply grounded and less common beauty. We should perhaps mention that these later portraits were mostly of foreigners, and often of Americans. There is wonderful work in some of these portraits, stone as pure and untouchable as antique cameos. There are faces whose smiles are nowhere defined; they play softly among the features, rising like a veil with every breath. Lips close mysteriously and eyes wide with dreams look beyond everything, into an eternal moonlit night. And yet Rodin always inclines toward a representation of the woman's face as a part of her beautiful body, as if her eyes were the eyes of her body and her mouth the mouth of her body. Where he sees and creates in this organic way, the face often takes on such a strong and moving expression of unexpected life that it completely supercedes the portrait as a whole (even if the whole figure appears to be more polished).

It is different with the images of men. It is easier to think of a man's essence being concentrated in his face. We can even imagine that there are moments – those of quiet as well as those of inner excitement – when all of life is captured in a man's face. Rodin chooses such moments when he decides to do masculine portraits. Or even better: he creates them. He goes far afield. He doesn't settle on the first or second impression, or on those that follow. He observes and makes notes. He notes movements unworthy of discussion, turns and half-turns, forty reductions and eighty profiles. He surprises the model in his habits and mishaps, in forming expressions, in exhaustion and strain. He gets to know all the transitions in his features, where smiles come from and where they go. He observes the man's face like a scene he takes part in himself; he is in the middle of the action, indifferent to none of it, and nothing that happens escapes him. He doesn't want to hear anything about the man, and he doesn't want to know anything other than what he sees. But he sees everything.

He spends a good deal of time with each bust. The material grows to a certain point in drawings, in a few strokes of the pen or brushes of color, and also in his memory, for Rodin developed his memory into a resource that is at once

reliable and always ready. During the sittings his eye sees far more than he can record at the time. He forgets none of it, and often the real work begins, drawn from the rich store of his memory, only after the model has left. His memory is wide and spacious; impressions are not changed within it, but they adjust to their surroundings, and when they pass into his hands it is as if they were the entirely natural gestures of these hands.

This method leads to massive combinations of hundreds of life's moments: and this too is the impression we receive from these busts. The many distant contrasts and unexpected transitions that make up a person and their constant development join together here in auspicious union, holding one another fast by an inner force of adhesion. These people are assembled from the full breadth of their beings, and all the climates of their temperament are revealed in the hemispheres of their heads. There is the sculptor Dalou, in whom a nervous exhaustion vibrates beside a tenacious, almost petty energy; there is Henri Rochefort's adventurous mask; there is Octave Mirabeau, with the dreams and longings of a poet dawning behind the façade of the man of action; and Puvis de Chevannes and Victor Hugo, whom Rodin knew so well; and perhaps above all, the indescribably beautiful bronze portrait of the poet Jean-Paul Laurens. The surface of this bust is so profound and at the same time so great in its conception, so restrained in its bearing and strong in its expression, so alert and full of movement, that we wonder whether nature itself took this work from the hands of the sculptor, to hold and preserve it as one of her most precious possessions. The magnificent patina, its smoky black surface pierced by metal shining like shooting flames of fire, contributes enormously to the perfection and uncanny beauty of this sculpture.

There is also a bust of Bastien-Lepage, beautiful and melancholy, bearing an expression of the suffering artist whose every effort represents one long parting from his work. It was made for Damvillers, the painter's hometown, where it stands in the churchyard cemetery. So this piece is in fact a monument. But in their completeness and breadth of conception, all Rodin's busts have something monumental about them. With this one, however, there is a greater simplification of the planes, an even more rigorous selection of that which is essential, and all with an eye toward being viewed from a distance. The monu-

ments created by Rodin tended increasingly to fulfill these conditions. He began with the memorial of Claude Gelée for Nancy, and it is a steep ascent from this first, rather interesting attempt to the grandiose achievement of *Balzac*.

Many of Rodin's monuments were taken to the Americas, and the most mature of them was destroyed in Chile before it was even placed in position. This was the equestrian statue of General Lynch. Like Leonardo's lost masterpiece, which it may very well have approached in its force of expression and in the wonderfully animated oneness of horse and rider, this statue was not meant to survive. Based on a small plaster model in the Rodin Museum at Meudon, we can only conclude that the image was that of a thin man sitting erect in the saddle, not with the brutal arrogance of a mercenary but rather with a kind of nervous tension; more like a man who dutifully exercises his authority than one who has made it his life. Even in this cast, we can see the general's hand pointing forward, emerging from the massive foundation of man and beast. It is this same feature that lends an unforgettable majesty to the gesture of Victor Hugo, that sense of having come from afar, that force compelling us to believe at first sight. The great living hand of an old man who converses with the sea doesn't come from the poet alone; it descends from the summit of the whole group as if from a mountain on which it had been praying before it began to speak. Victor Hugo is the exile here, the solitary man from Guernsey, and it is one of the wonders of this monument that the muses surrounding him do not give the impression of figures come to visit the forsaken old man: on the contrary, they are shades of his solitude become visible. Rodin achieves this impression by internalizing each of the figures, and by concentrating them all around the poet's inner self; here again, by giving individual life to the points of contact, he succeeds in making these wonderfully vital figures seem to be expressions of the man who is seated. They surround him like great gestures performed once before, gestures so young and beautiful that a goddess granted them the favor of immortality, to endure forever in the form of beautiful women.

Rodin made many studies for the figure of the poet himself. During Hugo's receptions in the Hôtel Lusignan, he withdrew to a window niche, where he observed and noted all the old man's movements, and every expression on his animated face. Rodin's various portraits of Hugo were derived from these

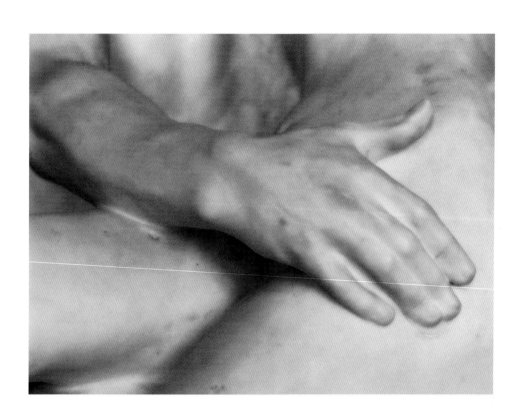

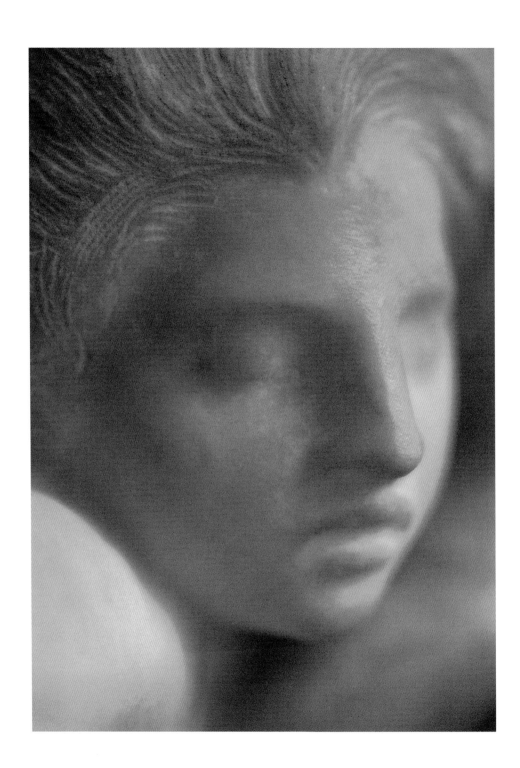

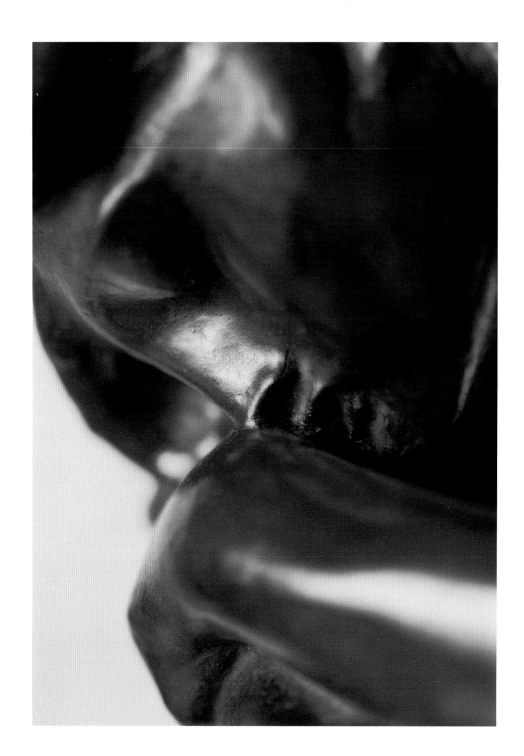

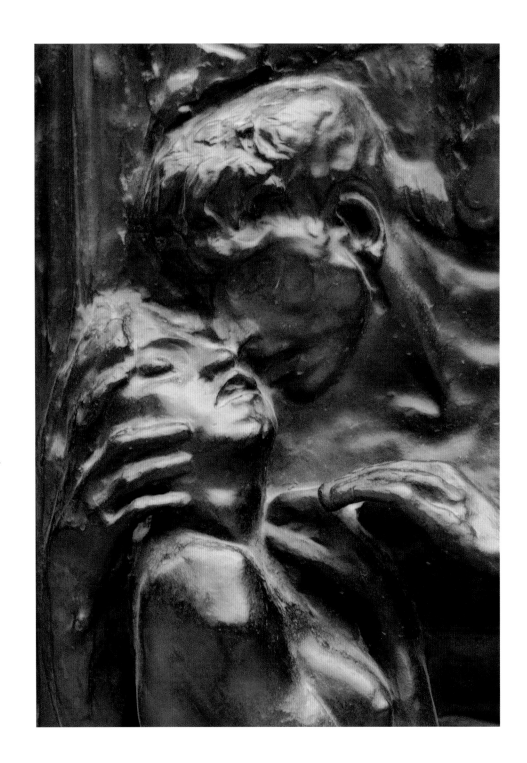

preparations. But he had to delve even deeper for the monument. He removed himself from all the individual impressions and ordered them from a distance. Then, just as the single figure of Homer was likely created from a series of rhapsodes, Rodin created this single image from all that was in his memory. And he provided this final image with the greatness of the legendary; as if in the end it might all have been a myth that could be traced back to massive rocks looming up from the sea, in whose strange outlines distant peoples had seen a sleeping gesture.

Where historical characters or material seek to live again in his art, Rodin has always had the power to reveal that which is timeless in the past. The best example of this may well be *The Burghers of Calais*. The historical material for this work consisted of just a few columns in the Chronicle of Froissart. It was the story of how the town of Calais was besieged by Edward III, how the English king refused to show mercy toward this town gripped by hunger, and how in the end he agreed to lift the siege only if six of its most distinguished citizens would deliver themselves to his hands, "for him to do with them as he pleases." He demands that they leave the city wearing nothing on their heads, clad only in shirts, each with a rope around his neck and the keys to the fortified city in hand. The chronicler describes the scene in the town; he reports how the mayor, Jean de Vienne, orders that the bells be rung, and how the burghers assemble in the town square. They wait in silence, having heard the terrible news. But then the heroes among them begin to stand up, those chosen ones who feel called to die. At this point the wailing and weeping of the crowd can almost be heard in the historian's words. He himself seems moved for a moment, as if his hand were trembling as he wrote. Then he collects himself. He names four of the heroes, but appears to forget the other two. He says of the first that he was the richest man in town. Of the second he tells us that he had power and prestige, and "two beautiful young ladies for daughters." Of the third man he knows that he was rich in possessions and inheritance, and of the fourth only that he was the brother of the third. He reports how they removed all but their shirts, tied ropes around their necks, and set out with keys to the fortified city. He tells how they arrived in the king's camp and describes how harshly they were received, and how the executioner had already come up

behind them when his lord, upon the request of his queen, decided to spare them. "He heeded the words of his wife," Froissart writes, "because she was with child." That is all there is in the chronicle.

But this little material was enough for Rodin. He felt immediately that there was a moment in this story when something great happened, something that knew no dates or names, something entirely independent and simple. He turned his complete attention to the moment of their departure. He saw how these men began to walk. He felt how each of them was filled with the whole life they had lived, how each one stood there, weighted with his past and ready to carry it out of the city. Six men appeared before him, of whom no two were alike. There were only two brothers among them, and the resemblance, if any, was vague. But each one of these men had come to a decision and lived through this last hour in his own way, rejoicing in spirit and suffering in body, which still clung to life. And then he no longer saw these figures. Gestures arose in his memory, gestures of rejection, renunciation, and farewell. He collected them. He formed them all. They flowed to him from the fullness of his knowledge. It was as if hundreds of heroes rose up in his memory, willing to be sacrificed. And he took these hundreds and made of them six. He formed them nude, each of them alone in the expressiveness of their shivering bodies. They were more than life-size, as befitted the natural proportion of their resolve.

He created the old man with arms hanging down as if his joints were loose, and he gave him a heavy, dragging stride, the worn-out gait of an ancestor, and a tired expression, which flows over his face and into his beard.

He created the man who carries the keys. There is life in him for many years to come, and it is all concentrated in this last sudden hour. He can hardly stand it. His lips are pressed together, and the key cuts into his hands. He has set his strength on fire, and it is burning within him, in his brave defiance.

He created the man who bows his head and holds it in his hands, as if to collect himself, to be alone for one more moment.

He created the two brothers, one of whom looks back, while the other lowers his head in a motion of decisive submission, as if he were already offering it to the executioner.

And he created the vague gesture of that man who "passes through life,"

whom Gustave Geffroy has referred to as *le passant*. He walks along, but then turns back one last time, not to see the town, nor those who are weeping or those walking with him. He turns around, back to himself. His right arm is raised, bent ambivalently at the elbow; his hand opens in the air and releases something, as if he were setting a bird free. It is a parting from all uncertainty, from a happiness not yet realized, from a sorrow that now will wait in vain, from people who live somewhere, and whom he might have met at some point, from all the possibilities of tomorrow and the days to come, and also from a notion of death as something distant, gentle and silent, something that would come only after a very long time. This figure, placed by itself in a dark, forgotten garden, would make a fitting monument for all who have died young.

In creating these last of life's gestures, Rodin gave life to each of these men.

The single figures are sublime in their simplicity. One might think of Donatello, and perhaps even more of Claux Sluter and his prophets in the Chartreuse of Dijon.

It appears initially as if Rodin had done nothing more to unite them. He has provided them all with the same shirt and rope, and placed them beside one another in two rows; the three who are already walking are in front, while the others behind them turn to the right, as if in the act of joining them. The piece was originally designed for the town square in Calais, to be placed on the very spot where the arduous journey once began. These silent images were meant to stand there on a low platform, raised only slightly from the daily life of the town, as if the ghastly procession might commence anew at any given moment.

Because it was contrary to custom, however, the people of Calais rejected the prospect of such a low pedestal. And so Rodin proposed a different setting. He asked them to build a square tower with plain hewn walls, with roughly the same dimensions as the base of the sculpture and a height of nearly two stories. It would rise at the seashore, and provide a place for the six figures to stand in the solitude of the wind and sky. Not surprisingly, this suggestion was rejected as well, in spite of the fact that it was clearly in keeping with the essence of the work. Had they tried it, we would have had an incomparable opportunity to admire the unity of the group, which consists of six separate figures fused together as if they were a single thing. And yet the individual figures did not

touch one another; they stood side by side, like the last trees of a felled forest, united only by the air, which seemed to be part of them in an extraordinary way. Walking around this group, it was astonishing to see how the gestures rose pure and great from the rhythm of the contours, how they surged, paused for a moment, and then fell back into the mass, like flags being furled. Everything there was clear and distinct. There was no room for chance. As with all Rodin's groups, this one was self-contained, a whole world in itself, filled with a life that circulated without escaping at any point. Overlapping contours replaced the contact of planes here, although these contours too were a form of contact, reduced infinitely by the intervening medium of the air, which influences and changes them. Contacts from a distance came about, forms encountered one another and overlapped, like layers of clouds or mountains, where the air separating them is not an abyss but a gradual transition, an indication of direction.

The interaction of the air with the work it surrounds was always enormously important for Rodin. He designed his Things and their planes in relation to space, and it is this that gives them that greatness and independence, that indescribable maturity, which distinguishes them from all other things. But now that his interpretation of nature had gradually led to an emphasis on expression, it became apparent that the relation of the atmosphere to his works had intensified as well, so that it surrounded the intersecting planes in a more compelling, passionate way. If his Things had simply stood in space before, now space drew the Things into itself. One rarely sees anything comparable to this effect, but some of the animals on cathedrals have it. There, too, the air seems to commune with the figures: it seems to become calm or windy as it passes alternately over places of emphasis and relief. In fact, when Rodin elevates the surfaces of his works, when he creates the highest points and gives greater depth to the cavities, the result closely resembles the way the atmosphere interacts with things that have been exposed to it for centuries. For the air too has elevated, deepened, and covered with dust, conditioning things with rain and frost, with sun and storms, for a life that passes more slowly, if also more prominently, in dark perpetuity.

Rodin was on his own way to this effect with *The Burghers of Calais*. The

monumental principle of his art was already realized in this work. With these means he was able to create things that were visible from a great distance, things that were surrounded not just by the air around them, but by the whole sky. He could catch and reflect the distances as if with a mirror, and he could form a gesture that seemed immense, forcing space to commune with it.

A good example is the slim young man who kneels and extends his arms upward and backward in a gesture of boundless appeal. Rodin called this figure *The Prodigal Son,* but somehow it took on the title *Prayer,* which it quickly outgrew as well. For it is not simply a son kneeling before his father. This gesture makes God necessary, and in he who performs it are all who need him. All expanses belong to this stone; it is alone in the world.

The same is true of *Balzac.* Rodin gave him proportions that may actually exceed those of the writer. He captured the essence of his being, but he did not stop with the boundaries of this essence; he sketched mighty contours that extend beyond the man's achievements to encompass his ultimate, most distant possibilities, contours prefigured in the gravestones of distant ancestors. He was completely absorbed by this figure for years. He visited the countryside of Touraine, where Balzac grew up and to which he returns repeatedly in his books, he went through his correspondence, he studied the existing portraits, and he read his works again and again. He encountered Balzac's characters on all the winding paths of this work, whole families and generations, a world that seemed to have an undying faith in the existence of its creator, to live through his life and to gaze fondly on him. He saw that these hundreds of characters, whatever their various functions might be, could all be traced back to the man who had created them. And just as one can guess which play is being performed from the expressions of the audience, he searched all these characters' faces for the man who had given them eternal life. Like Balzac, he believed in the reality of this world, and he succeeded for a while in inserting himself into it. He lived as if Balzac had conceived him as well, unnoticed among the multitude of his creations. He learned a great deal in this way. Everything else appeared much less eloquent. The daguerreotypes offered general points of reference, but certainly nothing new. The face they showed was familiar from portraits he had seen in school. Only one of them, which belonged to Stéphane

Mallarmé and which showed Balzac in suspenders and without a coat, was more characteristic. Then he enlisted the accounts of his contemporaries, from the words of Théophile Gautier to the notes of the Goncourts, and the extraordinary sketch of Balzac by Lamartine. Aside from that there were only the bust by David in the Comédie-Française and the small portrait by Louis Boulanger.

Filled wholly with the spirit of Balzac, Rodin now proceeded to construct his outer appearance with the assistance of these aids. He used live models of similar physical proportions to make seven figures in various positions, all of them brilliantly accomplished. The men he employed for this task were heavy, sturdy types, with thick legs and short arms, and the result of the preliminary studies was a Balzac very much like the man depicted in the daguerreotypes of Nadar's age. But he felt sure nothing final had yet been given. He returned to Lamartine's description. There was written: "His face was elemental," and: "He was so filled with soul that it carried his heavy body as if it were nothing." Rodin felt instinctively that a large part of his task lay in these sentences. He came closer to a solution when he tried to put all seven figures in the hoods of monks, imitating Balzac's favored attire for working. The result was Balzac in a cowl, far too intimate, too withdrawn in the silence of his clothing.

But Rodin's vision grew, moving slowly from form to form. And at last he saw him. He saw a broad, striding figure, shedding all his weight in the fall of the cloak. A powerful neck met the hair, and drawn back into this hair was a face, watching, in a rush of watching, seething with Creation: an elemental face. This was Balzac in all his prolific abundance, founder of generations and squanderer of fates. This was a man whose eyes needed nothing; had the world been empty, he would have filled it with his gaze. This was the man who sought his fortune in fabled silver mines, and happiness in foreign love. This was Creation itself, in all its presumption, arrogance, frenzy, and ecstasy, making use of Balzac to appear in this form. The head, thrown back, perched on the peak of this figure like balls dancing on the spray of fountains. All heaviness had become light, and it rose and fell.

In a single moment of tremendous concentration and tragic exaggeration, Rodin had seen his Balzac, and this is the way he made him. The vision did not pass; it was transformed.

This development in Rodin's work, which surrounded the great and monumental things in his work with breadth, also endowed the others with a new beauty. It provided them with a distinct nearness. Among the more recent works there are small groups marked by an extraordinary unity of composition and a wonderfully tender treatment of the marble. These pieces retain at midday the mysterious shimmer emanated by white objects at twilight. This is not due solely to the vitality of the points of contact; a close look reveals that flat marble bands have been left between some of the figures, and these crosspieces connect the individual parts of one form with another in the background. This is no accident. These bands of stone prevent the observer from pointlessly looking through and beyond the thing, and into empty space. They preserve the rounded contours of the forms, which tend to appear sharp and worn down in the gaps, and they gather the light like bowls with a constant, gentle overflow. While Rodin seems to have intended to draw the air as close as possible to the surface of his things, here it is almost as if he had dissolved the stone in it: here the marble appears to be a firm, fecund core, and the pulsating air its last, most delicate contour. The air that comes to this stone abandons its will; it doesn't pass beyond this piece to other things; it embraces the stone, hesitates, lingers, and lives in it.

This obstruction of all unessential vision represented a kind of approach to the relief. In fact, Rodin is planning to make an immense relief in which all the light effects he achieved in the smaller groups are to be brought together. He has a large column in mind, around which a broad band of relief is to wind its way upward. An interior staircase is to rise alongside these spirals, closed off to the outside by vaulted arcades. The figures will live in their own atmosphere on the walls of this passageway, and the result will be an art that knows the mysteries of *clair-obscur*, a sculpture of twilight, akin to the figures that stand in the vestibules of ancient cathedrals.

This will be a *Monument to Work*. A history of work will be developed on the slowly rising relief. The long scroll will begin in a crypt, with images of men growing old in the mines, and its broad path will pass through all the forms of human occupation, from the loud and vigorous to the increasingly taciturn, from blast furnaces to the work of the heart, and from the work of

hammers to that of the brain. Two figures will loom at the entrance, Day and Night, and two winged deities will crown the summit of the tower, blessings descended from illustrious spheres. And this monument to work will indeed be a tower. Rodin would not think of representing work with a single great figure or gesture, for it is not something to be viewed from a distance. It belongs in the workplace, in the small rooms of craftsmen; in heads and in darkness.

This he knows well, for he himself is constantly working. His life passes like a single workday.

He has a number of ateliers. Some are well known to visitors and correspondents, others are secluded and known to no one. These are bare cells, sparsely filled with gray and dust. But their poverty is like the great gray poverty of God, in which the trees awaken in March. There is something of early spring in these spaces: a quiet promise and deep solemnity.

Perhaps the tower of work will rise one day soon in one of these workshops. Now, while it remains to be realized, we can only speak of its meaning, and this appears to lie in the material. When the monument is finally in place, it will be obvious that with this work, too, Rodin wants nothing beyond his art. The working body has revealed itself to him just as the loving body had before. It was a new revelation of Life. But this creator lives so completely in his things, absorbed entirely in the depths of his work, that he can only respond to these revelations with the simple means of his art. To him new life essentially means new surfaces and new gestures. In this sense life has been simplified for him. He can no longer go wrong.

Rodin's development has provided a sign for all the arts in this confused age.

One day people will recognize what made this artist so great: that he was a worker who desired nothing more than to give himself completely, with all his strength, to the humble and difficult world of his craft. There was a kind of renunciation of life in this, but with patience he gained it back: for the world came to his work.

PART II (1907)

THERE ARE A FEW GREAT NAMES
that would establish a sense of solidarity between us if I were to pronounce
them here and now, a warmth and unanimity that would make it appear as if I
– only apparently isolated – were speaking from among you, as if I were one of
your voices. But the name that presides over this evening like a constellation of
five brilliant stars cannot be spoken. Not now. It would only disturb you, setting
in motion currents of sympathy and hostility, while I need your silence and the
unclouded surface of your obliging anticipation.

I beg those of you who still can to forget the name in question, and I request
of all an even wider forgetting. You are accustomed to hearing people speak
about art, and who would deny that you are particularly well inclined to words
addressed to you in this sense? A certain strong and beautiful movement has
fixed your gaze like the flight of a great bird, a movement that could no longer
be concealed: and now you are asked to lower your eyes for part of an evening.
For I have no desire to draw your attention to the firmament of uncertain devel-
opments. Nor do I wish to prophesy based on the bird flight of modern art.

I come before you to remind you of your childhood. No, not of yours, but
rather of all that ever was childhood. For it should be possible to awaken mem-
ories that are not yours, memories that are older than you. I shall seek to restore
connections and renew relationships that came about long before you.

If I intended to speak of people, I could begin right where you left off when you came into this room. Picking up on your conversations, I would naturally come to everything – lifted and swept along by this exhilarating age, on the shores of which everything human seems to lie, inundated by it and mirrored in unexpected ways. Reflecting on my task, however, it has become clear to me that I have not come before you to speak of people, but rather of things.

Things.
When I say the word (are you listening?), it grows silent; the silence that surrounds things. All motion subsides and becomes contour, and something permanent is formed from the past and the future: space, the great calm of things, liberated from desire.

No, you do not feel it growing silent. The word "things" means nothing to you – too much and thus too ordinary – and passes right by. And in this sense it is good that I have evoked childhood; perhaps this sense of something precious, something associated with many memories, can help me bring this word home to you.

If possible, I ask you to return with your mature, refined sensibility to one of the things that was most familiar to you as a child. Try to remember if there was anything in the world that was closer, more familiar, and more necessary than this thing. Was it not the case that everything else in the world could cause you pain or treat you badly, frightening you with pain and confusing you with uncertainty? If kindness, trust, and the sense of not being alone could be counted among your earliest experiences, do you not owe it to that thing? Was it not with a thing the first time you shared your little heart like a piece of bread that would have to suffice for two?

Later you would find a holy joy in the legends of the saints, a blessed humility and a readiness to be all things, and you would recognize it because some small piece of wood had once taken on the same qualities for you. This small, forgotten object, which was willing to mean almost anything, made you familiar with thousands of things by playing thousands of roles; it was animal and tree, king and child, and when it receded, all these things were there. This something, worthless as it was, prepared the way for your first relationships

with the world; it introduced you to life and to people. And what's more: in its Being and its outward appearance, in its final destruction or its mysterious slipping away, you experienced everything human, deep into death itself.

You will hardly remember these things, and you are rarely conscious of the fact that even today you still need things, which, like the things of your childhood, require your trust, love, and devotion. How can things become so important? How are things related to us at all? What is their story?

Human beings began forming things very early. With great difficulty, and following models provided by the things they found in nature, people made tools and vessels, and it must have been a strange experience initially to view what they had made with their own hands as just as right and authentic as what really existed. Things came into being blindly, in the fierce throes of work, still warm with the traces of an open, dangerous life – but no sooner were they finished and set aside than they took their place among other things, assumed their composure and quiet dignity, and looked out from their own permanence with a distant, melancholy consent. This experience was so remarkable and so great that it is not difficult to imagine how things soon came to be made for their own sake. The earliest images of gods may well have been manifestations of this experience, attempts to form something immortal and permanent from the human and animal world, something belonging to a higher order: a thing.

What kind of thing? A beautiful one? No. Who would have known what beauty is? A thing bearing some resemblance. A thing in which one recognized what was loved and feared, and the incomprehensible in all of it.

Do you remember such things? Perhaps there is one that has long seemed simply ridiculous. But one day you were struck by its urgency, the particular, almost desperate earnestness all things have; and did you not notice how a beauty came over this image as if against its will, a beauty you would not have thought possible?

If you have experienced moments like this, I wish to invoke them now. For in these moments things are brought back to life. No thing can move you if you do not allow for it to surprise you with an unimaginable beauty. Beauty is always something we come to, but we don't know what this something is.

The notion of an aesthetic sensibility that is capable of grasping beauty has led you astray, and produced artists who understand their task to be the creation of beauty. It bears repeating in this context that beauty is not "made" at all. No one has ever made beauty. We can only create variously agreeable or sublime conditions for that which sometimes dwells among us: an altar and fruit and a flame. Nothing beyond that is in our power. And the thing itself, which evolves irrepressibly in human hands, is like the Eros of Socrates, it is the *daimones,* between god and man, not necessarily beautiful itself, but pure love and longing for beauty.

Imagine how completely this insight changes everything when it dawns on an artist. The artist who is guided by this knowledge does not need to think of beauty; in fact, he knows no better than anyone else what it consists of. Directed by an urge to fulfill a purpose far beyond himself, he knows only that there are certain conditions under which beauty may come to the things he makes. And his calling consists of getting to know these conditions, and gaining the ability to produce them.

But those who study these conditions thoroughly soon learn that they do not pass beyond the surface and nowhere penetrate the core of the thing; and that the most one can do is to produce a surface that is self-contained and in no sense fortuitous, a surface which, surrounded, shadowed, and illuminated like natural things by the atmosphere, is absolutely nothing but surface. Removed from the pretentious and capricious rhetoric, art returns to its humble, dignified place in everyday life, to craft. For what does it mean to produce a surface?

Let us consider for a moment whether everything before us, everything we perceive and explain and interpret, does not consist simply of surfaces. And as for what we call mind and soul and love: are they not all just a subtle change on the small surface of a nearby face? And doesn't the artist who has formed this surface have to keep to the tangible element that corresponds to his medium, to the form he can lay hold of and imitate? And wouldn't the artist who is capable of seeing and recreating all forms provide us (almost without knowing it) with all the life of the spirit? With everything that has ever been called longing or pain or bliss, and with everything that cannot be named in its indescribable spiritual vitality?

For all happiness that has ever thrilled the heart; all greatness that has

nearly destroyed us with its force; every broad, transforming thought – was once nothing but the pursing of lips, the raising of eyebrows, the shadows on a face: and this expression on the mouth, this line above the eyebrows, this darkness on a face – perhaps they were always there in exactly the same form: as a marking on an animal, as a crack in a rock, as a bruise on a piece of fruit …

There is really just one single surface, which undergoes thousands of shifts and transformations. We could think the whole world in this thought, if only for a moment, and it would become a simple task in our hands. For the question as to whether something can come to life does not depend on great ideas, but rather on whether he makes of them a craft, an ongoing project that remains with him to the end.

At this point I dare to mention the name that cannot be withheld any longer: Rodin. As you know, this is the name of countless things. You ask to see them, and I am confused because I cannot show you a single one.

But I almost feel as if I could see some of them in your memory, as if I could lift them out and place them before us:

that man with the broken nose, unforgettable as a suddenly raised fist;

that young man who stretches up in a motion as familiar as your own awakening;

that walker, upright like a new word for walking in the vocabulary of your feeling;

and the one who sits, thinking with his whole body, withdrawing into himself;

and the burgher with the key, like a great repository of pure pain.

And Eve, bent into her own embrace as if from a great distance, her hands turning outward to reject everything, including her own changing body.

And the sweet, soft, inner voice, armless like life within and separated from the rhythm of the group.

And some small thing whose name you have forgotten, made from a shimmering white embrace that holds together like a knot; and the other that may be called Paolo and Francesca, and still smaller ones you find within yourself, like fruits with very thin skin –

And then your eyes, like the lenses of a magic projector, cast a gigantic

Balzac on the wall behind me. The image of a creator in all his hubris, erect in his own motion as in a vortex that inhales the whole world into his seething head.

And now that these have been called from your memory, shall I draw on others from these hundreds of things? On Orpheus, Ugolino, or Saint Theresa receiving her wound? On Victor Hugo with his commanding gesture, oblique and massive, and the other figure, oblivious to all but the whispering voices, and then still a third, serenaded from below by three maidens' voices, like a spring bursting from the earth to meet him? And I can already feel how the name falls apart in my mouth, how it all is simply the poet, the same poet who is called Orpheus when his arm extends beyond all things to the strings, the same one who clings in pain and anguish to the feet of the Muse as she escapes, and who dies in the end, his face upright in the shadow of the voices that fill the world with song. A death so impressive that this small group is often called *Resurrection*.

But who can stop the surge of lovers rising up on the sea of this work? Fates draw near in the relentless connectedness of these figures, with sweet names of little comfort, but suddenly they vanish like a passing radiance – and we understand why. We see men and women, men and women, again and again, men and women. And the longer one looks, the simpler the content becomes, until one sees simply: things.

At this point words become inadequate and I return to the great discovery I began preparing you for, the knowledge of the one surface with which the world offered itself to this art. Offered, but not yet gave. Accepting it would (and still does) require endless work.

Consider for a moment how much work would be required for an artist who wished to master all surfaces; after all, no one thing is just like another. He wasn't concerned with knowing the body in general, nor the face or the hand (none of which exists anyhow); but rather all bodies, all faces, all hands. This is a task! And how simple and serious it is, how completely devoid of temptation and promise; how completely unpretentious.

A craft develops that appears to be that of an immortal; it is so broad, so

infinite and beyond boundaries, and so dedicated to a process of constant learning. Where to find a patience adequate to this craft?

This worker renewed it endlessly with love. And that is perhaps the secret of Rodin, that he was a lover who could not be resisted. His desire was so lasting and passionate and uninterrupted that all things yielded: the things of nature and the mysterious creations of all those ages in which human beings had longed to be nature. He didn't dwell on those who are easily admired. He sought to learn every element of admiration. He took on the difficult, reticent things, carrying them like a burden, and their weight pressed him further into his craft. It must have become clear to him under this pressure that what matters with art objects, just as with a weapon or a scale, is not how they look or the "effect" they create; rather, the most important thing is that they be well-made.

This workmanship, this working with the purest conscience, was everything. Recreating a thing meant going over every part, concealing nothing, betraying nothing; knowing hundreds of profiles, every angle and overlap. Only then was a thing there, only then was it an island, separated completely from the continent of uncertainty.

This work (the work on the *modelé*) was the same in everything one made, and it had to be done so humbly, so obediently, so devotedly, so impartially on the face and the hand and the body, that names no longer mattered; one simply gave to matter without knowing what would result, like a worm making its way from place to place in the dark. For who can be uninhibited when confronted by forms with names? Isn't there inevitably some selection involved in calling something a face? But the creative artist has no right to select. The artist's work must be imbued with a spirit of unyielding dutifulness. Forms must pass unembellished through his fingers, like something entrusted to him, in order to be pure and intact in his work.

And the forms in Rodin's work are pure and intact; without questioning, he transferred them to his things, which look as if they have never been touched when he finishes with them. Light and shadow grow soft around them as they do around very fresh fruit, and more alive with movement, as if the morning wind had brought them.

Here we must speak of this movement, although certainly not in the common reproachful sense; for the motion in the gestures of this sculpture, which has been widely remarked, takes place within the things, like the circulation of an inner current, never disturbing the calm and stability of their architecture. But the introduction of movement into sculpture does not in itself represent a significant innovation. This kind of motion is new, however, where the light interacts in extraordinary ways with the singular composition of these surfaces, the inclines of which are so multifarious that the light flows slowly in places, then falls precipitously in others, appearing shallow and then deep, glossy then flat. The light that makes contact with one of these things is no longer just any light, it no longer undergoes incidental changes; the thing takes possession of this light and uses it for its own purposes.

Rodin reestablished this acquisition and appropriation of light by way of clearly defined surfaces as an essential quality of sculpture. Various solutions to this problem had been attempted in classical and Gothic sculpture, and he placed himself in the most venerable traditions when his development finally led to the mastery of light.

Some stone really does have its own light, such as the lowered face on the block in the Luxembourg Museum. This figure called *La Pensée* [Thought] leans forward into shadow, coming to rest above the white shimmer of the marble, under whose influence the shadows dissipate and pass into a vaguely luminous transparency. And who could forget one of the smaller groups, where two bodies create twilight and encounter one another in its veiled softness? And it is truly extraordinary to see the light pass slowly over the prone back of *The Danaid,* as if it were inching forward for hours. And did anyone else still know the full extent of shadow, which would have to include the shy, transparent darkness we find around the navel in small pieces of antiquity, and which now can only be found in the concave shape of rose petals?

The course of progression in Rodin's work lies in such barely describable steps. With the taming of light the next great achievement began as well, that quality which gave form to his things, that greatness beyond all measure. I refer to the way he comes to terms with space.

Here again, as so often before, things were of the essence, and so he

74

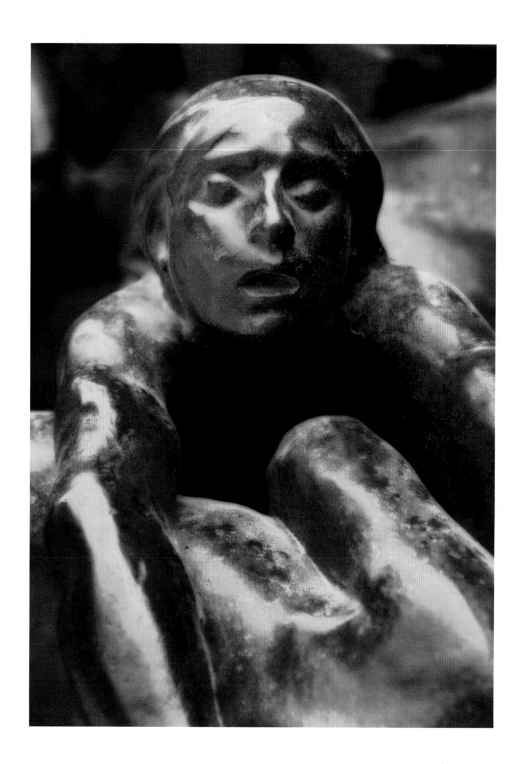

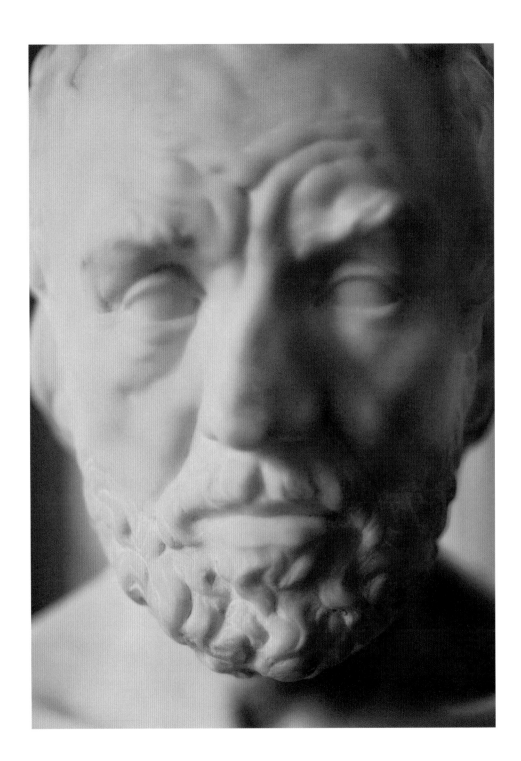

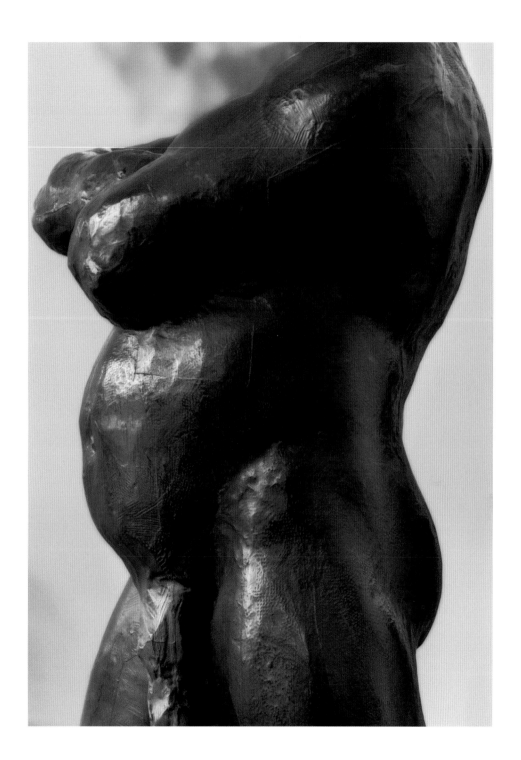

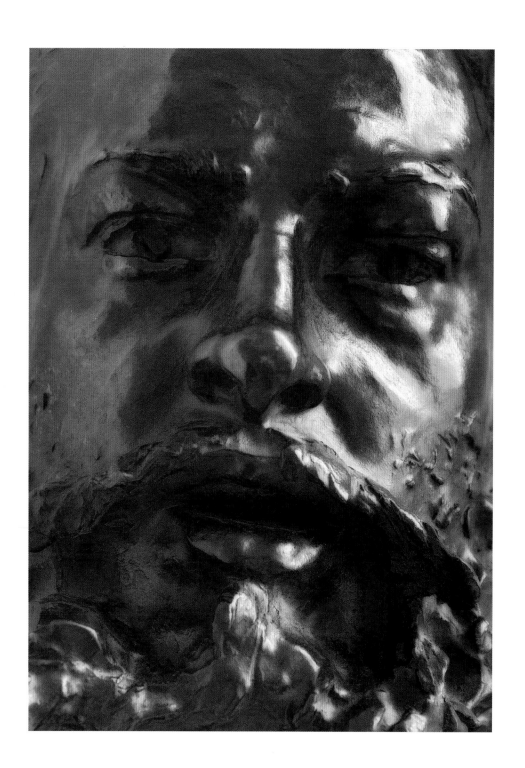

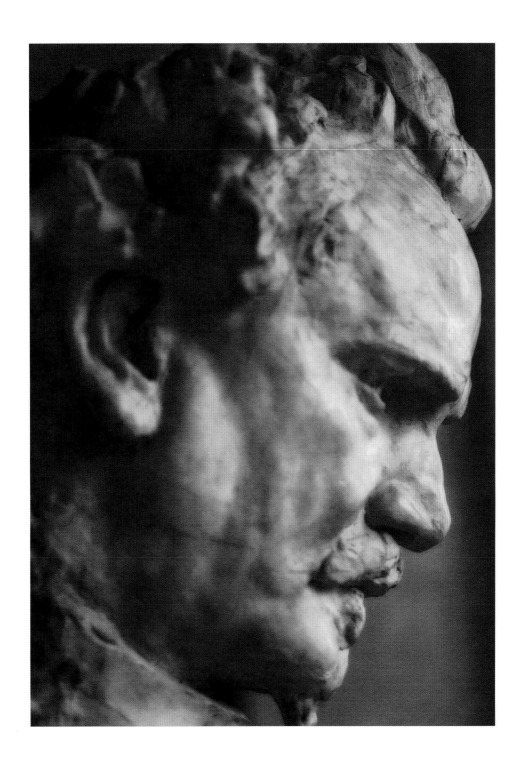

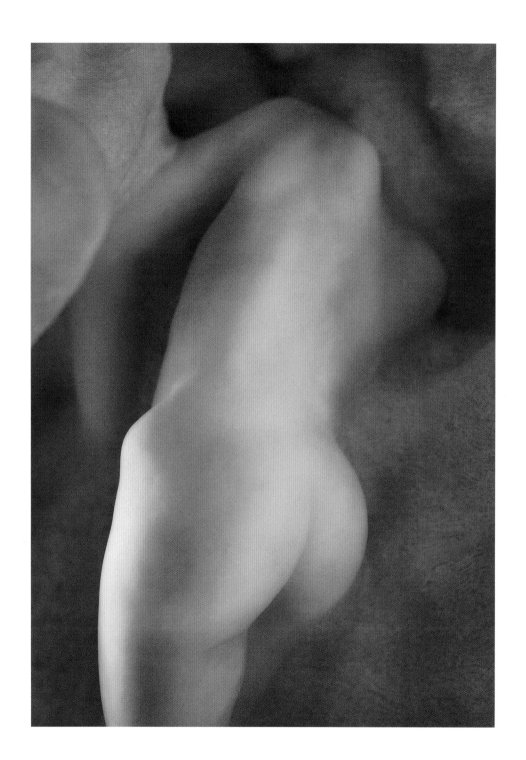

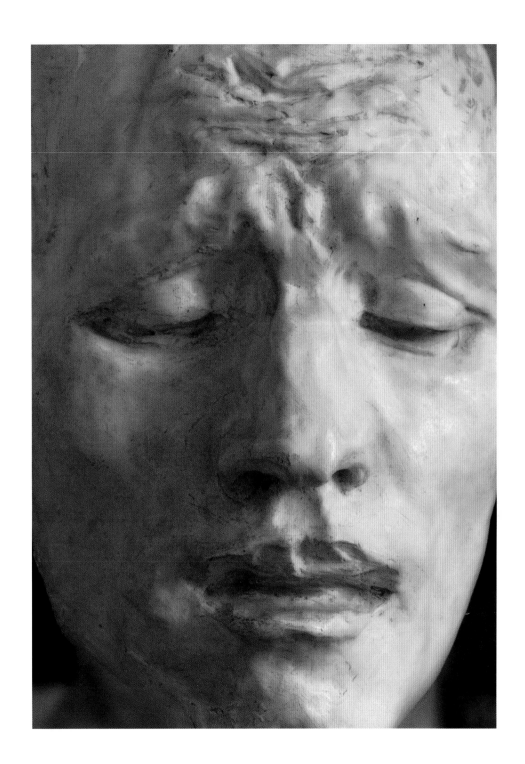

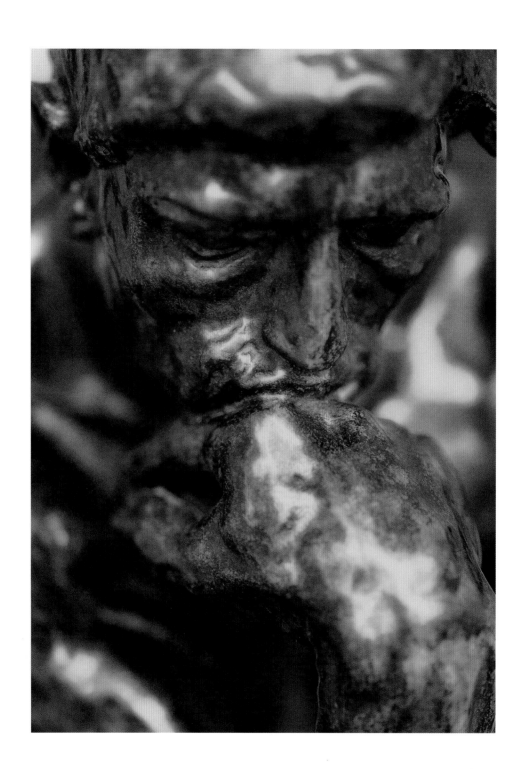

returned again and again to question things found in nature as well as individual art objects of sublime origin. They responded repeatedly with the constancy animating them, and gradually he came to understand. They revealed a mysterious geometry of space, which taught him that the contours of a thing must be arranged in the direction of planes inclining toward one another for a thing to properly take its place in space, to be recognized, as it were, in its cosmic independence.

It is difficult to describe this knowledge precisely, but we can observe how it was applied in Rodin's work. The given details are brought together with increasing energy and certainty in strong individual units, until finally they take form, as if under the influence of rotating forces, in a number of great planes, and we get the sense that these planes are part of the universe and carry on into infinity.

There is *Youth of a Primitive Age,* who stands as if in an interior space. And *John,* around whom space recedes in all directions. And the whole atmosphere surrounds *Balzac* – but there are also a number of headless figures, the giant new walker among them, who seem to pass far beyond us, into the universe, to dwell among the stars in vast, unerring spheres.

But just as in a fairy tale, where the giant who has been overpowered makes himself small for his conqueror in order to submit to him completely, so was the master able to make the space he had won from things into something belonging entirely to him. For this space in all its vastness can also be found in those strange sheets of paper, which could easily be mistaken for the high point of this work. These drawings from the last ten years are not, as they are often taken to be, superficial jottings or merely provisional, preparatory studies; they contain the ultimate expression of a long, uninterrupted experience. And this they contain, as if by continuous miracle, in what would appear to be nothing, in hasty outlines, in a contour derived breathlessly from nature, in the contour of a contour too delicate and precious for nature to retain. Lines have never been so expressive and yet so unintentional, even in the most extraordinary Japanese drawings. For there is no representation here, no plan or purpose, and no trace of a name. And yet, what is not here? What holding on or letting go or no longer being able to hold on, what bending over, stretching out, and con-

tracting, what falling or flying has ever been seen or imagined that is not to be found again here? If they had been seen somewhere once, now they were lost: for they were so fleeting and fine, so far removed from a single meaning, that no one had ever been capable of ascribing them one. And it is only now, when we see it unexpectedly in these drawings, that we understand this meaning: the extremes of love, suffering, despair, and bliss emanate from them, although we don't know why. There are figures that rise up, and this rising is as glorious as only a morning sun can be. There are light figures departing quickly, and their parting fills us with dismay, as if we could not live without them. There are figures lying down, surrounded by sleep and dreams; and languid figures heavy with lassitude and waiting; and depraved figures who cannot wait. We see their depravity, and it is like the growth of a plant, growing in madness because it cannot do otherwise. And we can sense that there is much of the bending of a flower in this bending figure, and that all of them are part of the world, even those figures which are remote forever like signs of the zodiac, held fast in their passionate solitude.

But when one of these animated figures becomes visible beneath a light shade of green, it is the sea or the ocean floor, and the figure moves differently, more arduously, under the water. And a touch of blue behind a falling form is enough to bring space tumbling onto the page from all sides, enveloping the figure with so much nothingness that one grows dizzy and reaches involuntarily for the hand of the master who is holding the drawing out in a delicate, generous motion.

And with that, I feel obliged to say, I have shown you one of the master's gestures. You want others. You feel prepared enough to put together outward and superficial features, transforming them into pieces of a personal picture. You wish to hear the sound of a phrase as it was spoken; you want to enter places and dates in an atlas of this work.

There is a photograph based on an oil painting. The image, while indistinct, is that of a young man at the end of the sixties. The simple lines on the beardless face are somewhat hard, but the clear eyes piercing the gloom join the various features in the mild, almost dreamy expression young people take

on under the influence of solitude; it is almost the face of a young man who was reading until it got dark.

But there is another picture, taken around 1880. It shows a man marked by activity. The face is gaunt, the long beard flows down carelessly to a broad, thick chest, over which the loose coat hangs. One feels as if one can make out reddened eyelids in the ashen, faded tones of the photograph, but the gaze from overtaxed eyes is resolute and confident, and there is an elastic, unbreakable tension in the bearing.

And then all at once, after just a few years, everything seems to have changed. Something final has come of what was temporary and indeterminate, something made to last. Suddenly this forehead is there, rocky and steep, from which a straight, strong nose descends with delicate, sensitive nostrils. The eyes lie beneath stony old brows, seeing clearly within and without. The mouth of a faun's mask, half concealed and augmented by the sensuous silence of new centuries. And beneath it the beard as if too long restrained, cascading downward in a single white wave. And the figure bearing this head, as if not to be moved from the spot.

And if we had to say what it is that emanates from this figure, it would be this: it seems to reach back like a river god and look forward like a prophet. This figure is not characteristic of our age. While it is precise and definite in its singularity, it loses itself in a certain medieval anonymity; it has a humble greatness reminiscent of the men who built the illustrious cathedrals. The solitude of this figure is not aloofness, for it is based on a close connection with Nature. Its virility is tenacious without being hard, which brings to mind a description offered by one of Rodin's friends, who would occasionally visit him in the evenings: "When he goes, he leaves a certain mildness behind in the soft light of the room, as if a woman had been there."

And in fact, those select few taken as friends by the master have experienced his kindness, which is elemental like the kindness of a natural force, like the kindness of a long summer day, which nourishes everything and fades only late in the evening. But even the people who visited briefly on Saturday afternoons have experienced this, when they found the master among finished and half-finished works in the two ateliers in the *Dépot des Marbres*. His courtesy

gives one a sense of security immediately, but the intensity of his interest is terrifying when he focuses. Then he takes on a concentrated gaze that comes and goes like the light cast by a lighthouse, but which is so strong that one can feel it getting light far beyond the immediate object of his attention.

You will have heard many descriptions of the workshops on Rue de l'Université. They are sheds in which the building blocks for this great work are hewn. Inhospitable as quarries, they offer no diversion; designed solely for work, they compel the visitor to take on the work of observation, and it is here that many have sensed for the first time how unaccustomed they are to this work. Those who learned it left enlightened, and soon noticed that what they had learned applies to everything outside as well. But surely these spaces were most remarkable for those who knew how to see. They often came from far away, guided by a sense of gentle necessity, as if they were fated to stand here one day, protected by these things. It was a completion and a beginning and the quiet fulfillment of a desire for an example somewhere among all the words, for the simple reality of achievement. And Rodin would join them, admiring along with them what they admired. For the dark and eminently unintentional method of his work, which led to a mastery of craft, made it possible for him to stand and admire the finished works once they were there, as if he had not wrought them himself. And his form of admiration is always better, more thorough, and more filled with rapture than that of any of the visitors. His indescribable powers of concentration are always an advantage. And when he magnanimously dismisses any suggestion of inspiration with an ironic smile, and claims that there is no such thing as inspiration, but only work, one recognizes instantly that inspiration has become constant for this artist, and that he no longer feels it come on because it never leaves him, and one understands the basis of his uninterrupted fruitfulness.

He greets everyone he cares about with a simple question: "Has the work been going well?" And when this can be answered affirmatively, there is a satisfying sense of nothing more to ask. For he who works is happy.

This solution was possible for Rodin's simple and undivided nature, with its vast sources of energy, and his genius made it a necessity. Only in this way could it encompass the world. His fate was to work like nature works, not like men.

Perhaps this is what Sebastian Melmoth was feeling when he went out alone, on one of those sad afternoons, to see *The Gates of Hell.* The hope of making a new beginning may have flickered once again in his half-crushed heart. Perhaps, if it were possible, he would have asked the man when he finally had a moment alone with him, "What was your life like?"

And Rodin would have answered, "Good."

"Did you have any enemies?"

"None that could keep me from my work."

"And fame?"

"It made work a duty."

"And friends?"

"They expected work from me."

"And women?"

"I learned to admire them in the course of my work."

"But you were young once?"

"Then I was like all the rest. You know nothing when you are young; that comes later, and only slowly."

As for what Sebastian Melmoth didn't ask, it has been on the minds of those who observe the master carefully, astonished by the enduring strength of this nearly seventy-year-old man, by the youthfulness in him, which is as fresh and unpreserved as if he were constantly replenished by the earth.

And you find yourself asking impatiently again: "What was your life like?"

If I hesitate to provide you with a narrative, as one usually does when describing a life, it is because the dates we know (and there are only a few of these) seem so impersonal and general in comparison with what this man made of them. Separated from everything that came before by the impassable mountain range of his mighty work, it is difficult to recognize the past. We have to rely on what the master himself has said on the subject, and what others have appended.

Of his childhood we know only that he was sent from Paris to a small pension in Beauvais when he was just a young boy. He quickly became homesick, and, being delicate and sensitive, he suffered in the company of strangers who

treated him harshly. He returned to Paris when he was fourteen years old and learned to work with clay in a small art school. From that point on, he was happiest when his hands were in this material, which always held a strong appeal. Everything associated with work gave him pleasure: he even worked during meals, or when he was reading or drawing. He drew when he walked down the street, and early in the morning he drew the sleeping animals in the Jardin des Plantes. And when the love of work failed, poverty drove him to it. Poverty, without which his life would be unthinkable; he never forgot that it made him one with the animals and flowers, having nothing among all those who have nothing, who depend on God alone.

When he was seventeen he went to work for a decorator, just as he would later work for Carrier-Belleuse in a factory in Sèvres, and for Rasbourg in Antwerp and Brussels. His life as an independent artist began, as far as the public is concerned, around 1877. It began with people accusing him of having made the statue of *L'Âge d'airain,* which was being exhibited at the time, by taking a cast from Nature. It began with an accusation. He probably would have forgotten this by now if public opinion had not continued in a mode of accusation and rejection. He doesn't complain, but as a result of the constant hostility, which has continued unabated, he developed a good memory for unpleasant experiences, a memory he – with his good sense for what is most essential – otherwise would have ignored. His abilities were already considerable at the time (it must have been around 1864) when he made the mask of *The Man with the Broken Nose.* He had already done a good deal of work as part of his obligations, but it was all marred by other hands and did not bear his name. The models he made for Sèvres were later found and acquired by Mr. Roger-Marx; in the factory they had been discarded along with the useless shards. Ten masks meant for one of the Trocadéro's fountains vanished from the spot as soon as they were placed there, never to be seen again. *The Burghers of Calais* never received the placement the master had suggested for them; no one wanted any part of an unveiling of this monument. In Nancy Rodin was forced to make alterations to the base of the statue of Claude Lorrain. You will remember the unprecedented rejection of *Balzac* by those who commissioned it, on the grounds that the sculpture inadequately resembled its subject. But perhaps you

overlooked those newspaper reports of some two years ago, when the plaster cast of *The Thinker*, which had been erected provisionally outside the Panthéon, was vandalized with an axe. Should another of Rodin's works be marked for the public sector one of these days, you will likely find a similar notice. For this list, which represents only a selection of outrages that seem to multiply endlessly, is surely incomplete.

It is not difficult to imagine how in the end an artist would move to take up the challenge in this war that was constantly being declared. Anger and impatience could easily have got the better of him, but entering the struggle would only have drawn him away from his work. Rodin's great victory lies in the fact that he persevered and responded to destructiveness the way Nature does: with a new beginning and heightened productivity.

If I feared the reproach of exaggeration I would be powerless to describe for you Rodin's activity after he returned from Belgium. His day began but certainly did not end with the sun, for long hours lit by a lamp invariably followed. Late at night, when there were no models available, his wife, who long shared his life with touching support and devotion, was always ready to enable more work in his shabby room. She was invisible as his assistant, concealed behind the many humble tasks left to her, but she could also be beautiful, as the bust called *La Bellone* and a later portrait forbid us to forget. And when she too tired in the end, the mind of Rodin was so filled with memories of forms that there was no need to interrupt his work.

The foundations of his whole immeasurable project were laid in these years; it was then that nearly all the well-known pieces came about, and with astonishing simultaneity. It is as if the beginning of its realization were the only sign that it would be possible to complete such a colossal undertaking. This immense power would continue undiminished for years on end, and when exhaustion finally set in, it wasn't due so much to the work as to the unhealthy conditions in the sunless apartment (on Rue des Grands-Augustins), which Rodin had long ignored. It is true that Rodin often longed for nature, and he occasionally went out on Sunday afternoons. But it was usually evening by the time he – walking along with the multitude (taking an omnibus was unthink-

able for years) – arrived at the fortifications, beyond which lay the countryside, indistinct and unattainable in the twilight. At last it was possible to follow his old dream, however, and move to the country; first to a little house in Bellevue and later to the high country of Meudon.

There life became much more spacious; the house (the one-storied Villa des Brillants with the high Louis XIII roof) was small and has never been enlarged. But now there was a garden, the cheerful cultivation of which became part of all that took place, and expanses right out the window. In these new surroundings it was not the master of the house who took up room and required constant expansion; now it was his beloved things that were to be indulged. No effort was spared for them. Six years ago, as you will remember, he moved the Exhibition Pavilion from the Pont d'Alma to Meudon, and left that bright and lofty room to the hundreds of things that fill it now.

A collection of classic statues and fragments, selected personally and with considerable care, has grown gradually along with this Musée Rodin. It contains a number of Greek and Egyptian works that would stand out in the rooms of the Louvre. In another room there are paintings behind Attic vases, and the artists who made them can be easily named without looking for signatures: Ribot, Monet, Carrière, Van Gogh, Zuloaga; and among those remaining unnamed, there are several that can be traced back to the great painter Falguière. Naturally, there are many dedications: the books alone form a vast library at once curiously independent of its owner and assembled with meticulous care. All these objects are surrounded by mindfulness and held in honor, but no one expects them to contribute comfort or atmosphere. One almost has the sense that singular art objects of widely varying kinds and times have never been experienced with such intensity as in this place, where they are free of the ambition that often characterizes collections, and where they are not forced to contribute their own beauty to a general sense of contentment that has nothing to do with them. Someone once said that they are kept there like beautiful animals, and this does capture Rodin's relation to the things around him; for when he moves among them at night, cautiously as if not to disturb them, and finally goes up with a small light to a piece of antique marble, which stirs, awakens, and suddenly rises from its sleep, it becomes clear that Life is what he

has been seeking, and what he is now admiring. *"La vie, cette merveille,"* is how he put it once.

Here in the solitude of his country home, he learned to embrace this Life with ever more faithful love. It reveals itself to him as if he had been initiated, no longer concealing itself from him, beyond any sign of distrust. He recognizes it in what is small and what is great; in what is barely visible and what is immense. It is in getting up and going to sleep, and it is there in his night watches as well. The simple old-fashioned meals – the bread, the wine – are filled with this Life as well. It is in the joy of dogs, and it is in the swans and the brilliant flight of doves. Every little flower is filled with it, and every piece of fruit. A simple cabbage leaf from the garden boasts of it, and rightly so. It shimmers merrily in the water, and it fills the trees with happiness. And how it takes possession of men and women when they relinquish their striving. How well the little houses stand, just as they should, in perfect harmony. And how gloriously the bridge leaps across the river at Sèvres; pausing, resting, gathering strength and then leaping over again three times. And far behind it Mont-Valérien with its fortresses, like a great work of sculpture, like an acropolis or an ancient altar. And these things too have been made by men who were close to Life: this Apollo, this tranquil Buddha resting on an open flower, this hawk, and then here, this lean torso of a boy, in which nothing is untrue.

Building upon these insights, which are invariably confirmed by things near and far, the master of Meudon's workdays proceeded apace. And workdays they remained, one like the next, except that now this too belonged to the work – this looking outward and being part of everything and understanding. *"Je commence à comprendre,"* he often says, and with a certain reflective gratitude. "And this is because I devoted myself seriously to something. He who understands one thing understands everything, for the same laws are in all. I learned sculpture, and I knew well that it was something great. I remember now how I once put sculpture in place of God throughout the *Imitation of Christ,* but particularly in the third book, and it was right in every sense."

You will smile now, and it is quite right to smile. The depth of this assertion is so unprotected one feels compelled to conceal it. But you understand that words like this are not made to be spoken as loudly as I must speak here.

Perhaps they only fulfill their mission if those who have received them attempt to order their life accordingly.

Rodin, in any case, is silent like all men of action. He rarely presumes to express his insights in words, for these are the tools of the poet, and he modestly places the poet far above the sculptor, who, as he once said with a resigned smile, standing before the beautiful group titled *The Sculptor and his Muse,* "must make inordinate effort, in his dullness, to understand his muse."

And yet what has been said of his conversation is true as well here: *"Quelle impression de bon repas, de nourriture enrichissante."* For the simple reality of the days he has experienced stands massive and reassuring behind every word he speaks.

Now you can understand that these days are full. The morning passes in Meudon; often several works in progress are taken up in different ateliers, with each brought forward a little. Business affairs intrude, bothersome and unavoidable. The master is not spared this worry and hassle, as few of his works are handled by art dealers. There is usually a model waiting already at two o'clock in the city, someone sitting for a portrait or a professional model, and it is only in the summer that Rodin succeeds in returning to Meudon before dusk. Evenings there are short and always the same, for at nine o'clock the household retires.

And if you were to ask about the distractions or exceptions to this schedule, the fact is there are none. Renan's notion, *"travailler, ça repose,"* has never been more accurate than it is here daily. But sometimes Nature unexpectedly prolongs these days, which look so much alike, adding time and whole seasons before the day's work begins; she doesn't permit her friend to miss anything. Happy mornings roust him up, and he shares in their life. He walks in his garden or he goes to Versailles to attend the awakening of the parks, as one once paid homage to the *levée* of the king. He loves the calm of these first hours. *"On voit les animaux et les arbres chez eux,"* he says cheerfully, and he rejoices in everything along the way. He picks a mushroom and shows it with pleasure to Madame Rodin: "See," he says excitedly, "and that takes only a night; all these lamellae were made in a single night. Now that is good work."

Farm country sprawls beyond the edge of the park. A yoke of four oxen turns slowly, plowing ponderously in the fresh field. Rodin admires the slow pace, its unhurried deliberateness, its richness. And then he speaks: "It is all obedience." His thoughts pass through their work in a similar way. He understands this picture, just as he understands the pictures sketched by the poets with whom he often passes his evenings. (It is no longer Baudelaire, but still Rousseau occasionally, and very often Plato.) And when the horns sound, quick and tumultuous, from the training grounds at Saint-Cyr, he smiles, for he sees the shield of Achilles.

At the next bend the road stretches before him, *"la belle route,"* as level and long as walking itself. And walking too is a joy. This he learned from his time in Belgium. Accomplished in his work but for various reasons just mildly intrigued by his partner at the time, he stole whole days to be passed outside. He often had a paint box with him, but he used it less and less, for Rodin realized that occupying himself with a single spot would only divert him from the joy to be had from thousands of other things, which he knew as yet so little. And so this became a period of intense observation. Rodin has called it his richest. The great beech woods of Soignes, the long white roads going out to meet the great wind of the plains, the bright inns, in which rest and mealtimes had something festive in all their simplicity (usually just bread tipped in wine – *"une trempête"*): this was the world of his impressions, in which each event entered as if with an angel, for he found behind all the wings of glory.

He is surely right to think back with a profound gratitude on these years of walking and seeing. They were a kind of preparation for the coming work, a kind of preliminary state in every sense, for it was then too that his physical condition took on the enduring strength that he would later exploit so ruthlessly.

Just as he took an inexhaustible vitality from those years, so even now he returns from a long morning walk, refreshed and eager for work. Happy as if he had received good news, he goes in to his things, and begins with one as if he had brought something beautiful for it. In the very next moment he is completely absorbed, as if he had been working for hours. And he begins, completing here and changing there, passing through the throng as if he were responding to the call of the things that need him. He forgets none of them; those in

the background wait patiently for their hour. As in a garden, not everything grows at the same rate. Blossoms stand beside fruits, and here and there are leaves on the trees. Did I not say that an essential characteristic of this titan is to have as much time as Nature, and to produce with equal abundance?

Let me say this again: it still remains a miracle to me that there is a man whose work has grown to such extraordinary proportions. But I will never forget the look of alarm that greeted me once, when I used this expression among a small group of people, to evoke for a moment the enormity of Rodin's genius. One day I understood that look.

I was passing through the vast workshops, lost in thought, and I saw that everything was becoming, but nothing was in a hurry. There stood the completed bronze *Thinker,* intensely concentrated within himself. But he also belonged in the growing context of *The Gates of Hell.* There was one of the monuments for Victor Hugo, advancing slowly toward completion, still under observation, open perhaps to alteration, and further along were other variations, still works in progress. The Ugolino group lay in waiting, like the unearthed roots of an ancient oak. Also waiting was the remarkable monument for Puvis de Chavannes, with the table, the apple tree, and the glorious spirit of eternal peace. That piece in the distance must be a monument for Whistler, and this quiet figure here will probably make the grave of some unknown person famous one day. It is not easy to find a way through it all, but in the end I arrive back at the small plaster cast of the *Tour du Travail,* which awaits a patron in its final form, someone who will raise among men the immense lesson of its images.

And here beside me is another thing, a quiet face attached to a suffering hand. The plaster has that transparent whiteness that can only be imparted by Rodin's tools. And on the stand, written and then crossed out again – *Convalescente.* And then I find myself among new, nameless things in progress; they were begun yesterday or the day before, or even years ago, but they have the same equanimity as the others. They don't keep track of time.

And so I asked myself for the first time: How is it possible for them not to keep track of time? Why is this immense body of work continually growing,

and where will it end? Has it no regard for its master? Can it really believe itself to be in the hands of Nature, like the rocks for which a thousand years pass as a day?

And with some consternation I had the sense that all the finished work should be cleared out of the workshops, in order to see what remained to be done in the coming years. But as I was counting the many finished works – the shimmering stones, the bronzes, and countless busts – my gaze was fixed by the lofty *Balzac,* which had been rejected and returned, only to stand there proudly now as if he wanted never to leave again.

Since that moment I see the tragedy embedded in the magnitude of Rodin's work. I feel more strongly than ever before that with these things sculpture has grown to a prodigiousness that can only be compared to antiquity. And this sculpture has been born in an age that has no things or houses or external objects. For the inner life that makes up this age is formless and intangible: it is, in short, in flux.

It was left to this man to grasp it; in his heart he was one who gives form. He took hold of everything that was vague, developing, and constantly changing – all of which was in him too – and gave form to it like a god; for transformation, too, has its god. It was as if he had taken molten metal and let it harden in his hands.

Perhaps part of the resistance that his work seems to encounter every-where can be traced to a sense of the force at work therein. In its time genius is always terrifying, but here where it constantly outstrips our age in its conception and in its realization, the effect is astounding, like a sign in the heavens.

One can't help but wonder where these things will go. Who will dare take them in?

And don't they evince their own tragedy, these radiant, lonely things that have drawn the heavens to them? That now stand there freely, unrestrained by the presence of walls? They stand in space. And have nothing to do with us.

Imagine a mountain rising up within an encampment of nomads. They would abandon the spot and move along for the sake of the flock.

And now we all are nomads; not because none of us has a home where we

can stay and work, but rather because we no longer have a common home. Because we must always carry around what is great in us, rather than dwelling, even if just periodically, in greatness.

And yet, wherever humanity really becomes great, it desires a home of universal, nameless greatness. When greatness emerged for the first time since antiquity, in the sculptured figures created by men who were also nomads in spirit and filled with change – how it rushed to the cathedrals, taking refuge in the vestibules and climbing doorways and towers as if to escape a flood.

But where could Rodin's things go?

Eugène Carrière once wrote of him, *"Il n'a pas pu collaborer à la cathédrale absente."* There was no place for him to collaborate, and no one worked with him.

In the houses of the eighteenth century, and in its orderly parks, he saw with some sadness the last face of an age's inner world. And patiently he recognized in this face the features of a fundamental connection with nature, a connection that has since been lost. He returned with more and more conviction to nature, counseling us to return *"à l'oeuvre même de Dieu, oeuvre immortelle et redevenue inconnue."* And when he says of a landscape, *"Voilà tous les styles futures,"* he offers sound advice for those who will come after him.

His things could not wait; they had to be made. He foresaw their homelessness long ago. The only choice he had was whether to suffocate them or to give them the sky around the mountains.

This was his work.

He raised his world above us in an immense arc, and made it a part of nature.